IMAGES
of America

SEATTLE'S
BEACON HILL

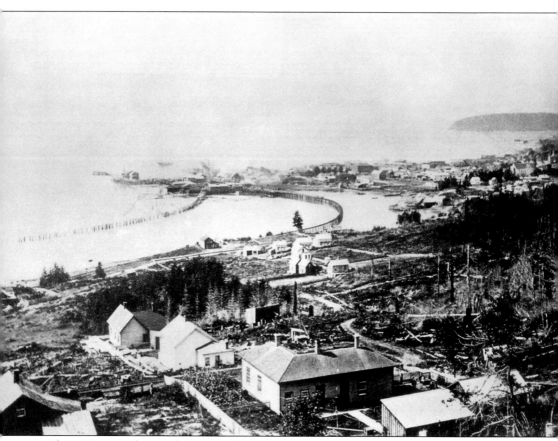

This 1879 view shows tide flats and houses on the western flank of Beacon Hill and downtown Seattle in the background. (MOHAI 15898.)

On the cover: Beginning in 1912, trolleys like the one in this photo carried passengers up to Beacon Hill from downtown Seattle. In the early 1940s, the trolley tracks were removed and electric buses took over the route. (PSRA TI-91.)

IMAGES
of America

SEATTLE'S
BEACON HILL

Frederica Merrell and Mira Latoszek

ARCADIA
PUBLISHING

Published by Arcadia Publishing
Charleston, South Carolina

Printed in the United States of America

Library of Congress Catalog Card Number: 2003113044

For all general information contact Arcadia Publishing at:
Telephone 843-853-2070
Fax 843-853-0044
E-mail sales@arcadiapublishing.com
For customer service and orders:
Toll-Free 1-888-313-2665

Visit us on the Internet at www.arcadiapublishing.com

This photo history is dedicated to Cy Ulberg, who inspired many of us to dedicate our time to improving our community, and to the South China Restaurant which served won ton soup and almond chicken on Beacon Hill for more than 40 years.

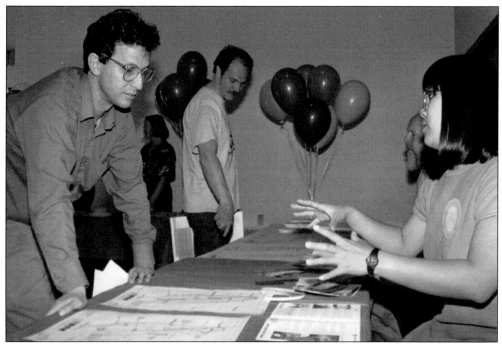

Cy Ulberg and Son Bao Vuong talk to neighbors at the North Beacon Hill Neighborhood Planning open house. (Seattle Department of Neighborhoods.)

CONTENTS

ACKNOWLEDGMENTS

Thank you to our neighbors who shared their stories and photos for this history book: Joe Belloti, Louise Bullington, Pete Caso, Ron Chew, Cheryl Chow, Bill DeVos, Gail DeVos, Don Duncan, Rose Ferraro, Giselda Forte, Joe Forte, Bob Griffin, Lee Hamre, Marge Haralson, Fumiko Hayashida, Clifford Holland, Dan Lagozzino, Kimball Lee, Sharon Lee, Frank Lioe, James Locke, Rebecca Lunn, Roberto Maestas, Frank Miyamoto, John Schreier, Rudy Simone, Bob Ohashi, Estella Ortega, Tom Rockey, Sharon Tomiko-Santos, Shigeko Uno, Gordon Yee, and Joyce Yee. Thank you to the following organizations, businesses, and individuals for providing photos, oral history transcriptions, and support for this project: Black Heritage Society of Washington State, Carol Tobin, Day Moon Press, DENSHO Japanese-American History project, El Centro de la Raza, Festa Italiana, Guy Roedruck at Media Plant, John Dickenson, John Fulton, Laura Martin, Museum of History and Industry (MOHAI), Paul Anastasia, Puget Sound Regional Archives (PSRA), Quintard Taylor, Seattle Municipal Archives, *Seattle Post-Intelligencer*, Seattle Public Schools, *Seattle Times*, St. George Parish, University of Washington Special Collections Library (UW), and the Wing Luke Asian Museum. Thank you to Kiyo and Rachelle at Imago imaging services for their help in scanning, formatting, and organizing the photos. Thank you to friends and members of the Jefferson Park Alliance for editing and support. With love and thanks to Robert and Fern Hinrix for smiling, cheering, and keeping us on track.

This project was funded by:

cultural
development authority of **King County**
King County Hotel / Motel Tax Fund

Seattle Department of Neighborhoods

Cleveland High School students in 1950 proofread the *Duwamish Diary*, the first history written of the Georgetown/Beacon Hill/Duwamish area. (Seattle Public Schools 012-135.)

INTRODUCTION

Beacon Hill is a community where immigrants from all over the globe and their descendants settled side by side for over one hundred years. The first people to wander the woods of what would later be called Beacon Hill were natives of the Duwamish tribe. Later trappers, traders, explorers, and early settlers walked the long north-south ridge of the hill. Pete Caso's parents immigrated from Tuscany, Italy, around 1912. Pete grew up on north Beacon Hill and remembers Serbians, Germans, Scottish, Swiss, Irish, a scattering of Japanese families, and many Italians living on the hill. Ron Chew, director of the Wing Luke Asian Museum, comes from a later generation. He grew up on the hill in the '50s and describes himself as a baby boomer born to parents from a Chinese village background. Ron Chew's neighbors were Filipino, Japanese, Chinese, African-American, and Euro-American. If one rides the Number 36 bus across the Jose Rizal Bridge to Chinatown, one hears dialects of Cantonese, Vietnamese, and Spanish, as well as eastern European languages. At Holly Park housing development on south Beacon Hill, many of the residents have immigrated from African nations torn by the strife of war, drought, and troubled economies. There is a section of southwest Beacon Hill, around Lucille Street and 13th Avenue South, which is still referred to as Maple Hill. Maple Hill was the first name given to the area in honor of Jacob Mapel, an early settler. At the early part of the last century, Maple Hill was home to a large concentration of European immigrants, including many Italians and Belgians. St. George Catholic Church, established around 1907, is a historic institution of this area. Today, the congregation of St. George boasts a large number of Filipino, Samoan, and Latino families, reflecting the shifts in the immigrant population of Beacon Hill.

At the turn of the century, most people of color, including Chinese, Japanese, Filipino immigrants, and African Americans, lived in a restricted zone of commerce and low-cost housing just south of downtown Seattle. The Jackson Street corridor, from the waterfront to about Ninth Street, has included the various historical locations of Chinatown, which started at the waterfront and moved east up the hill as the city developed. The early waves of Chinese, Filipino, Japanese, and African-American workers, who were mostly men, settled in the Jackson Street corridor in hotels and apartments built for single laborers. Arriving in the late 1800s these laborers worked in salmon canneries, built railroads, or were employed in the logging, mining, farming, and fishing industries. They were recruited as cheap labor for the manufacturers of products including wool, cigars, textiles, and shoes. Chinese men were also doing domestic work—laundry, cooking, and housecleaning—because there were so few women living in the area. Many African Americans worked for the railroads and the shipping lines as porters and stewards. Restaurants, hotels, cleaners, dry goods stores, and labor contractors were among the first businesses owned and operated by these residents. Today the area from Fourth Avenue to Ninth Avenue in the Jackson Street corridor is often referred to as the International District or "ID." In the Chinese community, it is still called Chinatown.

Beacon Hill has a special relationship to Chinatown/International District, along with the Central District. Beacon Hill and the Central District are the closest neighborhoods to the ID. These are the two neighborhoods that people moved to after getting a start in the ID. This is where growing young families went to find housing. Where other neighborhoods organized powerful barriers to the settlement of minority families, the Central District and Beacon Hill were affordable neighborhoods where families could more often succeed in finding housing. There were discriminatory barriers to people of color purchasing homes and renting apartments

in both the Central District and Beacon Hill, but they tended to be weaker than those barriers created in predominantly white, middle-class neighborhoods.

Professor Frank Miyamoto, from the University of Washington, grew up on Beacon Hill, and his parents came from southern Japan. His father's family was relatively poor but, as shopkeepers, had middle-class aspirations. Frank's mother came from a wealthier family involved in speculative mining. They were motivated to come to the United States in order to pursue opportunities for advancement that didn't exist in Japan, where social status was strongly pre-determined. Frank's father worked south of Enumclaw as a sawmill worker for five or six years. White workers at the mill tried to run the Japanese out and made it very unpleasant for the workers and their families. Frank's father sent the family away to safety, and they later moved to Seattle in 1910 to set up a furniture business.

When they arrived in Seattle, the Miyamotos settled in Nihonmachi, or Japantown, which at that time was clustered between Skid Road (Yesler) and Jackson Streets. The topography of the area was very different from today. There was a ridge connecting First Hill and Beacon Hill that cut straight across Dearborn Street. The shoreline and tide flats cut across from about First Avenue and Yesler Street to about Eighth or Ninth Avenue and Dearborn Street and skirted the western perimeter of Beacon Hill to the south. Originally, parts of Japantown were on stilts in the watered tideland areas.

Mr. Miyamoto's furniture business was thriving and he bought a house on Beacon Hill around 1919. According to Frank, the resistance to Asians moving into the area was noticeable, though not severe. His father refurbished second-hand furniture and also sold hardware, both commodities needed by new Japanese immigrants, but the business couldn't survive after Japanese immigration was curtailed in 1924. Japanese grocers were better able to make the transition to serving white customers. The Japanese grocers had superior fruit and vegetables and also created attractive displays that were neat and clean. This style of display is now typical in large grocery stores and, according to Frank, was learned from the Japanese grocers and fruit and vegetable sellers. Dye works and cleaners also transitioned easily to serve white clientele as the Japanese were thought to be very neat in their handling of clothes.

Frank attended first grade at the Main Street School on the corner of Sixth Avenue and Main Street in the heart of the Japanese community. Almost all the children were Japanese, but the teachers were all white. This school closed in the 1920s and Bailey Gatzert School was opened at Twelfth Avenue and Lane Street near the bridge to Beacon Hill. An Irish woman named Ada Mahon was the notoriously strict and demanding principal at both the Main Street School and Bailey Gatzert. It was her goal to make good American citizens of the children. She demanded that the children perform at a high level and was honored and appreciated by the Issei (immigrant-generation Japanese) parents who approved of her goals and methods. Frank moved to Beacon Hill in the second grade, where he encountered a new experience at the all-white Beacon Hill School. His first friend was a boy named Herbert Arnold who lived two or three doors away. Later he gravitated towards boys who were athletic, as sports were a means by which he could be accepted into juvenile society. He was small but fast and won acceptance among the *hajukin* (whites) by holding his own in scuffles.

The large Japanese community on the West Coast was interned in prison camps during World War II. The community was at the height of its prosperity and owned many businesses in Seattle at the time when President Roosevelt issued Executive Order 9066 in response to the bombing of Pearl Harbor. The order called for the internment, not just of Japanese immigrants, but of the entire Japanese community, including Japanese-American citizens living on the west coast. This was an unexpected shock for many people. Forcing the removal of American-born citizens of Japanese ancestry effectively eliminated the prosperous West Coast Japanese business community and caused many families to lose their homes. Sons and daughters joined their parents in the dusty camps. There was no one left to keep the family businesses operating, take care of family possessions, nor keep the homes occupied.

Professor Miyamoto talks about the impacts of the announcement of the bombing of Pearl Harbor:

By January, the newspapers became fairly vociferous in their attacks on Japanese. Some of the things that were being reported we felt sure were wild stories. For example, the Seattle Times carried a picture of a farming area north of Seattle where there were Japanese farmers. The allegation was that they had cut out an arrow pointing to Sandpoint Airport, north of the city, in a wheat field, or grass field. It was some kind of depression that looked like an arrow and was on a Japanese-American farm, and therefore was evidence of sabotage. We were of course terribly upset that stories of this kind were being spread in the newspapers. Things accelerated so rapidly that the Japanese Americans couldn't get organized rapidly enough to react against things that were happening. The evacuation announcement came as a bolt out of the sky. We were thinking that maybe things would resolve themselves favorably as a result of the Tolan hearings. On the other hand, when one attended the hearings, one was aware of the degree to which the sentiment was anti-Japanese, including Nisei [first-generation American born Japanese]. Only a rare voice would be heard in support of the Nisei. Then suddenly in early March, General DeWitt announced the exclusion order. There was concern that the Issei might be asked to leave, but there was no expectation that Nisei, Japanese-American citizens, would also be required to be removed. That was the shocking part of the DeWitt announcement.

After the internment, some of the scattered families returned to Seattle and settled in neighborhoods where they could buy or rent, like Beacon Hill. There was strong anti-Japanese sentiment in Seattle after World War II. Many families moved from the camps to other parts of the country and never returned to the West Coast. The internment severely disrupted the settlement patterns of the Japanese community in the Seattle area and interrupted their local history and cultural traditions. Many families lost belongings, including family photos. Institutions like the Japanese Language School were less central for the community after the war.

Shigeko Uno's family owned the White River Dairy on Weller Street. Their milk came from Japanese farmers in the White River Valley and was distributed to restaurants and grocers by truck. Like many businesses it was family run and everyone pitched in. When Shigeko was married, she and her husband worked at the dairy and her brothers also worked there after college. Shigeko and her husband Chick bought a home on Beacon Hill in 1936. Shigeko remembers the day her family heard news of the bombing of Pearl Harbor.

Of course, we couldn't believe it. We knew where Pearl Harbor was, but it was such a shock. We were really shocked. The same day my brother was supposed to announce his engagement to get married. Since we had made the arrangements, we had dinner, but nobody talked. We left as soon as we could. As we were coming down Main Street there was a Japanese restaurant. As we came down this stairway to the street level the FBI were there, and they picked up two of our friends who had been dining in the restaurant. They were American citizens. Their company had been dealing with Japan on the sale of steel, so for that they were picked up.

When the evacuation orders came through, we just couldn't believe our ears. For days, we heard the commentators, especially from California, saying "We're gonna put those Japs in camp, behind barbed wires." Chick and I would say, "Oh, that means our parents, because they are aliens." The law wouldn't allow them to become citizens. So we were saying, "We'll have to go visit them," not realizing that, my goodness, they meant us too.

By that time I was already pregnant and my second baby was supposed to come in May. When our orders came that we have to move in April, my doctor went down to the temporary camp, Camp Harmony, where the Puyallup Fair is today. He said, "Where's the hospital?" "We don't have a hospital," they replied. He was so horrified he wrote to the government. And they said, "If your patient is in the hospital, then she can stay there, but only as long as she can stay in the hospital." Fortunately, in those days, mothers had to stay two weeks in the hospital anyway, even though we wanted to go home. So I was able to stay in the hospital for two weeks.

I remember our last meal we had at home. My father-in-law had a poultry farm. Chick's brothers were at the farm and they brought in some chicken, the last chicken that they were going to eat. And they prepared this huge chicken dinner. And I thought, "Oh, I better ask the doctor if

9

I can eat," because I knew I was going to be induced the next morning. And he says, "Absolutely not." So all I could do was smell that delicious chicken dinner, which I never did have. Our family was supposed to evacuate on the 29th or 30th of April. The doctor had the baby induced. They give you this orange cocktail thing, and you drink it. And that started the labor pains, eventually. And so the baby was born on the 29th of April and the family was able to come to the hospital to see the baby. Then they left the very next day. So I guess I was sad. I remember this man who had helped my family came to the hospital to tell me that he had helped them get on the bus, and that they were safely on their way to Camp Harmony.

My husband called me from the camp, and says, "Order a kettle and pot and something to sterilize the baby's bottles," and little things like that. Of course, I couldn't carry the crib there. But he asked me to pick it up, so a friend of mine did. What a scene at the camp. It was dusty. And all the women had kerchiefs around their head to keep the dust out of their hair. There was barbed-wire fence and there were people outside looking in on the camp, as if we were the zoo. Those Sundays, when those hakujin (white) people would come by gawking, it was terrible, the feeling of it.

After the internment, Shigeko Uno and her husband stayed on the East Coast until 1947 because they thought it was dangerous to return to Seattle.

There were some cases up on Beacon Hill where there were signs over the barber and the hardware store, "No Japs Welcome." I think my husband didn't have the gumption I did. I always wanted to come home, because we had bought this house on Beacon Hill, and had it rented out. I knew I had a home to come to. Many of my friends, who had just rented a house, couldn't. There wasn't anything to come back to. But I had this real nice house. It was only a few years old.

In 1943, the 60 year-old Chinese Exclusion Act was eliminated, making it possible for waves of new Chinese immigrants to enter the United States. In 1949 the Chinese Communist Revolution reduced mobility between the United States and China. Prior to this time, Chinese workers came and went, earning money in the United States and returning to their homes and families in China for periods of time. After the Communist Revolution, the United States became a permanent place to live and raise a family. By the late 1950s many Chinese families had moved to Beacon Hill. For Beacon Hill, the shift to a predominantly Asian neighborhood, with larger percentages of African Americans, proceeded rapidly during and after World War II. Today Beacon Hill boasts a majority Chinese population.

With the growth of Chinese families after WWII came the growth of new traditions in the Chinese community. Former City Council member Cheryl Chow has coached girls' sports for many years. She grew up on Capitol Hill, living over the family restaurant. Her mother Ruby Chow started the Chinese Girls' Drill Team in Chinatown. Cheryl was the mascot for the drill team when she was really small and then grew into the job of managing the drill team as an adult. Chinese girls from Beacon Hill were recruited for the drill team and also played on the first basketball teams that Cheryl organized. The Seattle Chinese Athletic Association started out as a sports organization for Chinese boys. Cheryl Chow worked to expand the organization to include girls as well.

The waves of immigrants who have made a home on Beacon Hill shared common goals of access to employment, shops, and affordable family housing. Beacon Hill has had public transportation since 1912; at first, it was served by electric trolleys and small buses. Later, after the trolley tracks were removed, the bus lines ran the top of the ridge, north and south, and down to the ID and downtown Seattle. Over the years, workers from Beacon Hill have ridden trolleys, buses, and sometimes ferries to their jobs at restaurants, schools, shops, bakeries, garment factories, foundries, and shipyards.

When Bill DeVos' father was 17, in about 1909, he commuted to work from Beacon Hill to the Kirkland shipyards using the Lake Washington ferry.

In the 1920 census he was listed as a rivet heater. What they did, was they had a guy with a charcoal grill and he would have a handle and a blower on it and take the rivets in there until they were white hot and he would throw it to another guy. The other guy would catch it in a tin cup, pull it out and shove it through the hole and the third guy would rivet it. That's how he lost his hearing.

Later the DeVos family operated grocery stores on Beacon Hill. Their original store on Thirteenth South and South Angeline Street opened in 1917 and is still operating. They also had a store on Orcas and one on Beacon Avenue where the South China Restaurant is now. The DeVos family is of Belgian heritage, like many of their neighbors in that section of Beacon Hill. Among the DeVos neighbors was the family that owned the Jules Mae's Tavern in Georgetown.

Ron Chew remembers that all the women, including his mother, were garment workers, mostly in Pioneer Square.

Some of them worked along Rainier Avenue. There was Black Bear manufacturing and Far West garments on Rainier, Seattle Quilt Manufacturing Company was down in Pioneer Square, and Raffi's was further north. People lived on Beacon Hill but worked in Pioneer Square or Rainier Valley or Chinatown/International District. There was a glove factory in the leather shop near Jose Rizal Bridge so there were quite a number of Japanese women who worked there first in the 1940s and 1950s. The Chinese women started there later, in the 1960s. The buses took all these women down there on the Number 36 bus line to Chinatown and Pioneer Square and on the Number 7 bus line to Rainier Avenue.

For many years, Beacon Hill residents used the trolley lines to get to the Public Market on shopping days. According to Giselda Forte, you couldn't get a fresh chicken or fresh eggs on the hill.

I remember we built this house in 1950 and the first thing I invite all the brothers and sisters and all. I had a baby and couldn't go down to the market. Grandma went down to the market and bought two chickens for me. Later on, at one of the little storefronts, this man was selling stewing chicken and eggs.

According to Bob Griffin, the kids in his neighborhood on South Beacon Hill used the trolleys and buses to get to favorite swimming holes.

The buses used to run to Graham Street and hook up with the trolley. And they would just shuttle back and forth. Later on they ran down and did the loop on Byrd Street. The little shuttle was about the size of a small school bus and you could hear those things go by. The sides on them would go "bom, bom, bom," and you could hear them like a drum when they went down the street. We used them regularly. We would take the bus or walk up to the end of Graham and take that trolley to Madison Park and swim up there. It was easier to do that than to ride our bikes all the way down to Seward Park.

Besides swimming at Lake Washington, there were three other consistent sources of entertainment for Beacon Hill kids: the movies at the Beacon Hill theatre, the baseball games down at Sick's Stadium on Rainier Avenue, and Wickman's Pie Factory off Twenty-third Avenue. The Gray Goose Theatre was located in the Beacon Hill "junction" where Fifteenth Avenue South and Beacon Avenue meet. Just across the street was the Creamery, serving up ice cream and malts to the kids after the show. Marge Haralson was one of several longtime residents who remembers the theatre.

Sunday afternoon matinee, oh, man, that was the big deal. You took a quarter to get in and with that you could buy candy too. We saw the cowboy serials. You would come back the next weekend

11

to see the next one in the serial. They would end with the hero going over the cliff and you didn't know if he got out or not. Naturally you had to come back! There were about 30 or 40 parts in a serial. I would go with my brother or my sister and myself. As I got older, I could go by myself. I remember the Beacon Hill Creamery. It was the best ice cream. I remember sitting at the counter on a stool and I would always get a dish or a scoop of strawberry ice cream that I could eat on the way home. It was a hang-out for the kids after school.

The baseball stadium on Rainier Avenue and McClellan, at the base of Beacon Hill, was a short walk or bike ride for the kids of the area. The very first day that Roberto Maestas came to Seattle in the fall of 1955 he went to see his first baseball game in a real stadium.

I came into Seattle and connected with a half-Chicano, half-Anglo kid who I knew. It turned out that he lived in Georgetown. I was already a great baseball fan. I was 15 years-old and I knew about the Seattle Rainiers, the baseball team. I asked him, "You know, the baseball stadium? Where is it?" And he said, "It's just over that hill." And I said, "Can we go? Can we find it? Can we just go see the stadium? Maybe we can sneak in or what?" We walked across the hill from Georgetown and we stopped and played basketball in the old Beacon Hill School basketball court for a little while. We walked down to the stadium and it was the most beautiful stadium I had ever seen in my life. The outfield had grass and so on and so forth. I don't think we had the money to go in so we went up on the hill and watched some of the game. And then, maybe in the middle of the game, we got close to the stadium and we either were let in or we snuck in and we actually sat in the stands. I remember the first time I saw the game up close when we came into the stadium, about half-way through the game. Here I was looking at a triple-A baseball game and it was a dream-come-true. I am from northern New Mexico and that is what I know. We had basketball and baseball. Without basketball and baseball our lives would have been so empty. Whenever things got tough, horrible sad things, deprivation, and poverty, and all the shit that goes with it got hard, we would just get a baseball and play and play and play and play. We would play in the winter, summer, it didn't matter. That's why when I hit Seattle, everything is so moderate and mellow, that I could play ball . . . you know I would say "Let's go play baseball" and they would say, "No, its raining." And I would say, "That's not rain! That's mist." 'Cause we would play in the rain, the snow, the ice, it didn't matter, the blistering sun. Sports were extraordinarily significant.

Another consistently positive memory for a number of our oral history narrators was the Wickman's Pie Factory on Twenty-third and Harris Place. Harris Place no longer exists at this location, as this is the current site of Kimball Elementary School. Bob Griffin offered to share a funny story about Wickman's Pie Factory.

This one day, my friend Bill and I decided we were going down to Wickman's Pies to buy a pie. We were on the back of my motorcycle and we drove down to Wickman's Pies and we bought three pies. Two of us and we bought three pies. I ate my apple pie completely and Bill ate his pie, and we had a big meringue pie. We said, "Oh, I just can't eat anymore. Why don't we go up to Beacon, to the creamery up there, and get a malt and we can finish this other pie. Okay." So we came up Twenty-third, past the golf course, and we start north on Beacon Avenue. You know where South China is? Just south of there, there's a little group of buildings in there. They are all still there. There was an old building there with a storefront. Joe Rose, a kid who went to Cleveland High School with us, his family lived in this building. We are going down the street with Bill holding this other pie in the air like he was a waiter and I'm puttin' along on the motorcycle. Here is Joe Rose out in front of the building there polishing his '32 Ford. He's polishing away and he used to keep it just spotless. We got alongside there, and I don't know for what reason, Bill turned his hand over like that and the pie went down and hit the street. It practically didn't get anything on his car but it went all underneath the car and went all over this big plate window in

front of their building. All over the side of that building, like spilling milk. It just sprayed the whole front of that thing. For about two weeks I had eyes in the back of my head watching for old Joe Rose to catch up with me at that school. They had good pies, Wickman's Pies.

North Beacon Hill, along Beacon Avenue, used to be a busy business district. Today there is less business activity along Beacon Avenue from Holgate to Spokane Street than existed in the 1930s and 1940s. There were several changes after World War II that may have contributed to the decline of Beacon Avenue. The impact of the construction of the Interstate 5 freeway along the western flank of the hill in the early 1960s should not be underestimated. Access and homes were destroyed along the western flank of the hill. Increased numbers of family cars and the ensuing access to other shopping centers probably drew business away from the local groceries and bakeries. Neighboring business districts have grown significantly and provide stiff competition for customers. Beacon Hill has a close relationship to nearby Chinatown, which is easily accessible by bus and car. Beacon Hill residents shop, work, and socialize in Chinatown. Businesses in the nearby Rainier Valley to the east have expanded over the years as well. The economic slump of the 1970s may have also affected the community. Today Beacon Hill residents are hoping for revitalization of the Beacon Avenue business district. The city constructed a new library at Forest Street and Beacon Avenue in 2003 and the local transit authority is planning to build a train tunnel through the hill, with a connecting station on top, in the heart of the business district. Both these projects may lead to an increase in business activity on Beacon Avenue.

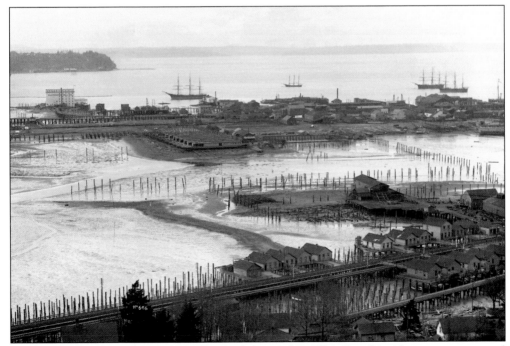

A 1900 photograph shows the tide flats and shipyard in Elliot Bay from the vantage point of Beacon Hill. (MOHAI 83.10.6049.2.)

Beacon Hill Timeline

1851	Henry Van Asselt stakes a 360-acre claim on the south end of Beacon Hill.
1851	Jacob and Samuel Mapel file claims to the north and call the area Maple Hill.
1853	John Holgate and John Hanford make claims to the north end of Maple Hill.
1855	Native Americans destroy the early settler buildings on Beacon Hill.
1865	The first tract of Beacon Hill is incorporated into the City of Seattle.
1866	African-American George Riley purchases 12 blocks of land on Beacon Hill.
1882	The first Chinese Exclusion Act barring Chinese immigration begins.
1886	An economic depression triggers anti-Chinese rioting.
1886	The Japanese government legalizes the shipment of contract workers.
1889	Union Army veteran M. Harwood Young moves to Beacon Hill.
1886	A direct steamship line is established between Yokohama and Seattle.
1899	The original Beacon Hill School begins operation.
1900	The original Maple School is constructed.
1901	The Cedar River water supply pipeline under Beacon Avenue goes into service.
1901	Eugene Semple attempts to sluice a canal through Beacon Hill at Columbian Way.
1904	An expanded Beacon Hill School (El Centro de la Raza) is constructed.
1907	The original Maple School is torn down to make way for the railroad.
1909	Old Maple School is constructed.
1909	Old Van Asselt School is constructed.
1909	The Jackson Street regrade begins.
1911	Two new water reservoirs in Jefferson Park go into service.
1912	Construction of the Twelfth Street Bridge, later renamed Jose Rizal Bridge, begins.
1915	Jefferson Park golf course opens.
1918	City Emergency Hospital for venereal disease and unwed pregnant mothers is built in Jefferson Park.
1927	Construction of Fire Station #13 occurs.
1931	The Japanese Golf Association annual tournament is held at Jefferson Park's 18-hole course.
1938	Sick's Stadium opens on McClellan and Rainier Avenue in the Rainier Valley.
1941	On December 7th the Japanese bomb Pearl Harbor, beginning the involvement of the United States in World War II.
1941	Seattle begins removing tracks for the old trolley system.
1941	The last Japanese-American Language School Picnic is held in May at Jefferson Park.
1941	The Armed Forces command creates a soldier recreation camp in Jefferson Park.
1942	Executive Order 9066, issued by President Franklin Roosevelt, orders the removal of all persons of Japanese ancestry from the West Coast of the United States.
1943	The 60 year-old Chinese Exclusion Act barring Chinese immigration is lifted.
1946	The City of Seattle gives 44 acres of land to the War Department to build Veteran's Hospital.
1947	Fir State Golf Club is formed by Black golfers in order to fight discriminatory club practices.
1957	Asa Mercer Middle School holds its dedication ceremony.
1972	A new Jefferson Park community center is constructed with Forward Thrust dollars for $280,000.
1972	War on Poverty activists occupy Beacon Hill School to form El Centro de la Raza.
1975	The first wave of Vietnamese immigrants flee the war in Vietnam.
1997	Neighborhood Planning for 37 communities, including North Beacon Hill, is initiated by the City of Seattle.
1999	Seattle Transportation builds median in Beacon Avenue between Spokane and Alaska Streets.
2000	Voter passage of Pro Parks Levy provides $8 million for the reconstruction of Jefferson Park

One
GEOGRAPHY
AND TRANSPORTATION

When I was about seven, I saw the steam shovels start from the waterfront and begin to cut their way north of our property. It never occurred to me that these far-off mechanical shovels might ultimately destroy the world I knew. The work went on for many years and it wasn't until the condemnation of South School, which my brother attended, that there was a growing restiveness among Hill residents.

—Eleanor Winslow

Beacon Hill rises to 350 feet above sea level on a ridge over three miles long running south of downtown Seattle. Before the early 1900s the ridge of Beacon Hill followed the line of the beachfront. The waves lapped at the beach, and the heavily wooded hill rose immediately from the water along its length. Like much of the Seattle waterfront the hills around the Sound presented a challenge to early Seattle pioneers and blocked transportation of goods and services from the east. Gritty and determined Seattleites accepted the challenge by undertaking monumental earthmoving and demolition efforts to clear passage for roads and access inland. In the rainy climate of the Pacific Northwest, stripping the land bare of trees and roots created slides and damage in many areas. Houses were demolished over the protests of homeowners, and whole neighborhoods were destroyed to be built again on topography so different as to be unrecognizable.

One identified problem was the steep ridge connection between First Hill and Beacon Hill. The Jackson Street regrade began in 1909 and cut away 85 feet from the ridge. The hill was sluiced hydraulically and the soil was washed down into the tidelands to help fill in what is now the industrial area south of the downtown core. The Holy Names Academy and the South School were razed in the process. Bailey Gatzert School was built in 1921 on the lower elevation in this area. South of Jackson street, on Dearborn, an even deeper regrade was undertaken that ravaged the north end of Beacon Hill and caused despair among homeowners on the north end of Beacon Hill. In 1909 this project lowered elevation by 112 feet, creating an enormous gap between Beacon Hill and First Hill, necessitating the construction of a bridge. The cut was dynamited and sluiced, filling in more tidelands for industrial use. The project caused slides and destroyed many homes. Much of the water for sluicing the hill came from the Beacon Hill reservoir in Jefferson Park.

There was one other early effort to change the topography of Beacon Hill. Eugene Semple, former governor of Washington, attempted to cut a hole through the middle of Beacon Hill to connect Elliot Bay to Lake Washington. He pledged to fill in 1,500 acres of tidelands with the sluiced soil. This effort, including dredging the Duwamish River, was called Semple's Canal. In 1901 many tons of soft earth, gravel, and sand were sluiced away from the side of the hill at Spokane Street before the hill began to cave in and the project was abandoned. Eventually a shipping canal was created north of downtown between Salmon Bay and Lake Union. Today the Interstate-5 freeway entrance from Beacon Hill winds up the steep canyon left by Semple's efforts.

The Twelfth Street Bridge, later renamed the Jose Rizal Bridge, was built in 1912. This bridge connects the two neighboring hills and provides the primary access to Chinatown/International District from Beacon Hill. Initially the steel bridge had a second level made of timbers. The second story bridge was constructed because the grade at the north end of Beacon Hill was higher than it is today. In 1923 the north end of the hill was further washed away to bring down the grade. With the north face of the hill level with the steel bridge, the wood trestle became unnecessary and was removed. Dearborn Street, once running west to east over the ridge, now runs 61 feet below the bottom of the Jose Rizal Bridge. Dearborn Street is a key transportation corridor connecting the Rainier Valley on the east flank of Beacon Hill to the industrial lands west of Beacon Hill and downtown Seattle.

The first county road to be constructed crossed Beacon Hill along the route of today's Beacon Avenue for much of its length. King County Road Number One came down the east side of Beacon Hill, where Cheasty Boulevard is today, wound around the hill to Yesler Way and went down Yesler to the Seattle waterfront. Another early road ran along the foot of Beacon Hill bluff, east of today's Airport Way. The was Beach Road and was built in the mid to late 1800s. Military Road, an early connection between Seattle and Olympia, was completed in 1860. Military Road traversed the western edge of the Beacon Hill beachfront and cut over the hill approximately where Columbian Way is today.

From the 1890s to the 1940s Beacon Hill was connected to the rest of Seattle by a street car running from Pioneer Square, along Jackson Street in Chinatown, and up onto the hill via the Twelfth Avenue Bridge. The trolley traveled the north-south spine of the hill along Fourteenth Avenue at the north end, through the "Junction" business district on Beacon Avenue, and terminated near Jefferson Park. People on the south end of Beacon Hill would get to the trolley via a shuttle that ran down to Graham Street. In the 1940s the streetcar became "trackless" and was extended down to Graham Street. One of the old trolley stops still exists near the fire station at Jefferson Park and has been recently refurbished by the Seattle Parks Department in cooperation with neighborhood groups and includes a newly planted fragrance garden. The neighborhood is currently served by the Route 36 bus, which follows much of the route of the old trolley, and other buses that connect residents with neighborhoods to the north, east, and west.

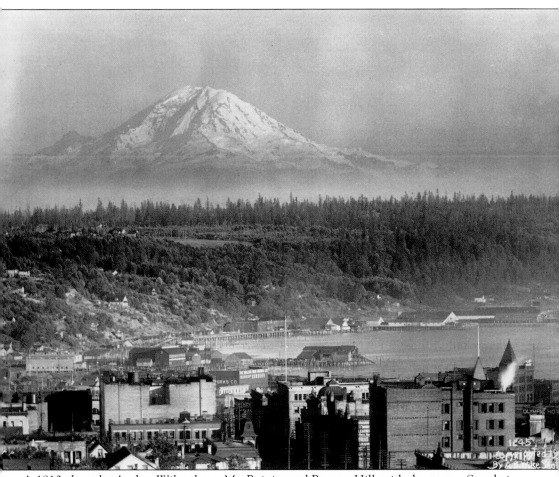

A 1910 photo by Anders Wilse shows Mt. Rainier and Beacon Hill, with downtown Seattle in foreground. (MOHAI 88.33.8.)

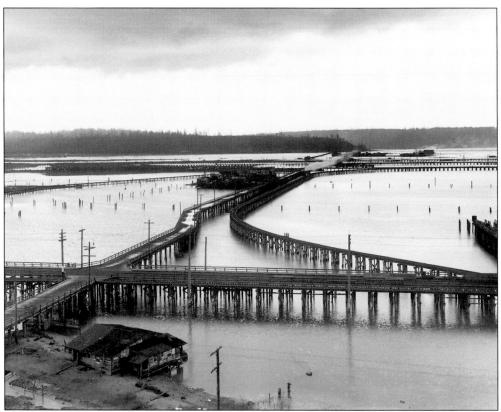

In 1900 railroad trestles ran above the tide flats near Beacon Hill. (MOHAI 83.10.7767.)

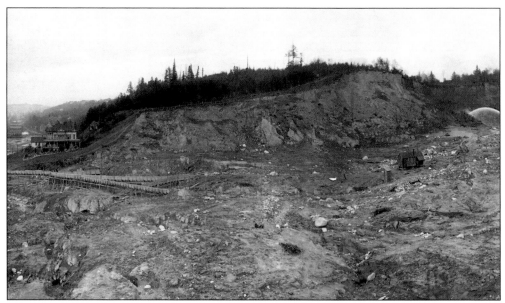

In 1901 Eugene Semple failed in his attempt to build a canal from Elliot Bay to Lake Washington through Beacon Hill. Later the Interstate 5 freeway exit to Beacon Hill was built here. (MSCUA UW 13700.)

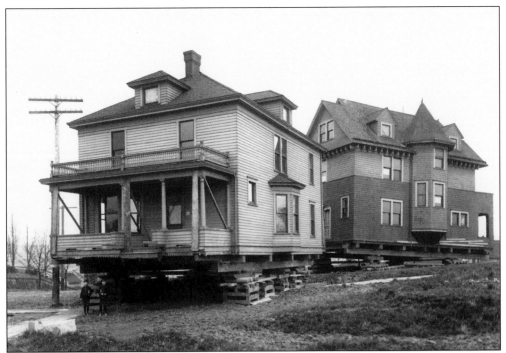

A 1906 photo by Asahel Curtis shows houses being moved on Beacon Hill during the regrade. (MSCUA UW CUR 07254.)

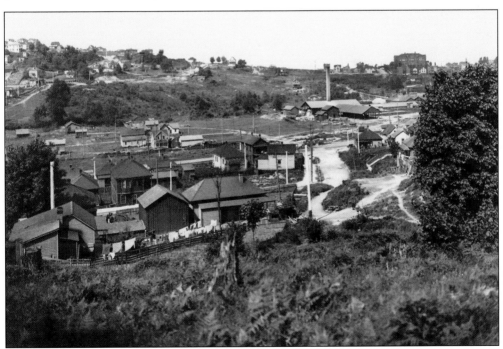

A 1906 photo taken by Asahel Curtis shows the eastern view of Beacon Hill with the Hill Brick Company located at Sixteenth and Dearborn Street. This photo was taken prior to the regrade of Dearborn Street. (MSCUA UW CUR 00497.)

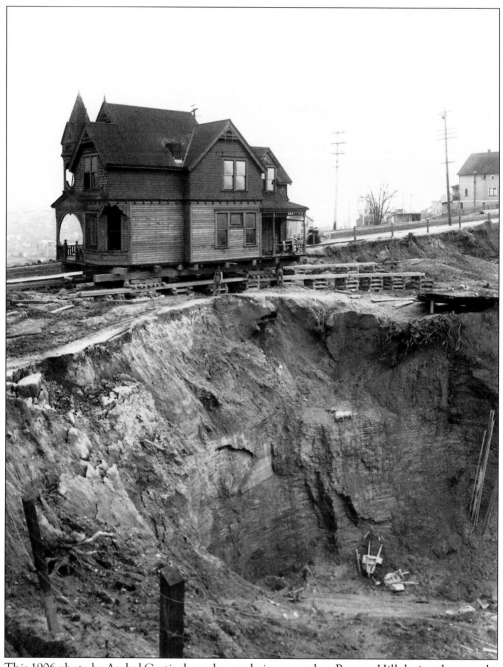

This 1906 photo by Asahel Curtis shows houses being moved on Beacon Hill during the regrade. (MSCUA UW CUR 07254-1.)

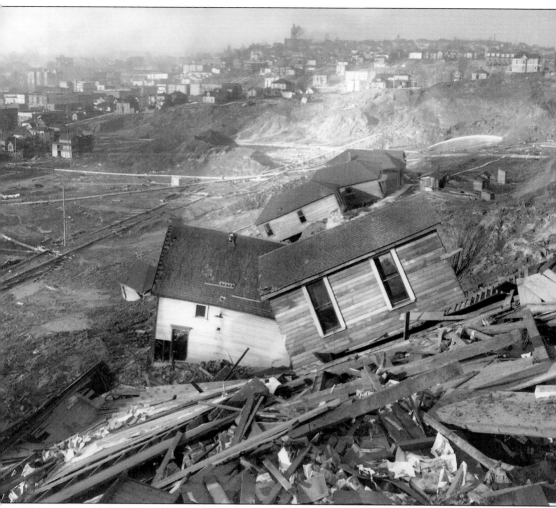

This view, *c*. 1909, from Beacon Hill shows the devastation of the Jackson Street regrade. (MOHAI 83.10.9115.2.)

These 1913 houses on lots 4 and 5, block 20, in Kidd's Addition are on regraded topography below Beacon Hill. (Seattle Municipal Archives 6525.)

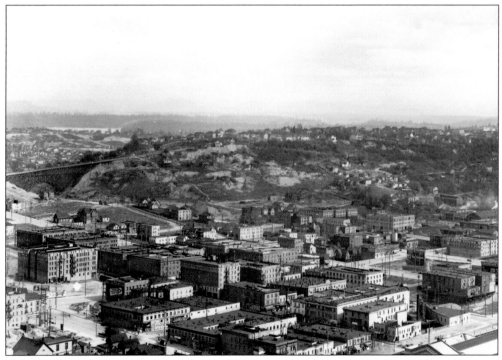

This 1913 view looks southeast to the Twelfth Street Bridge connecting First Hill and Beacon Hill. (MSCUA UW 5017.)

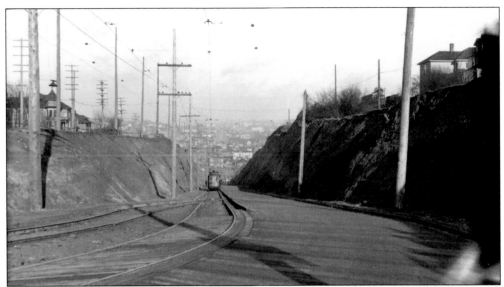

A 1917 view of the trolley climbing the steep incline on the north end of Beacon Hill near the Twelfth Street Bridge. First Hill can be seen in the background. (PSRA Seattle Transit NN-0727.)

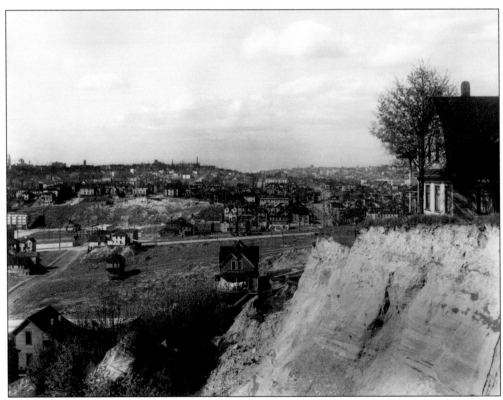

A 1914 photo by Asahel Curtis shows the regrade of Beacon Hill. (MSCUA UW CUR 29677.)

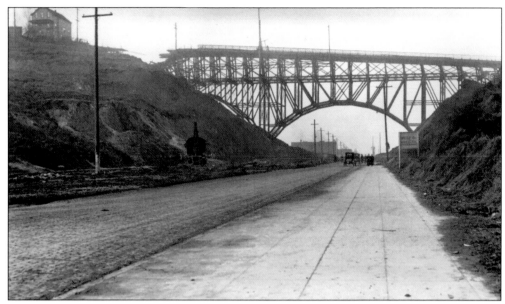

This 1917 photo of the damaged Twelfth Street Bridge was taken from below on Dearborn Street. A mudslide broke the wooden trestles loose on the south end of the bridge. (PSRA Seattle Transit NN-0771.)

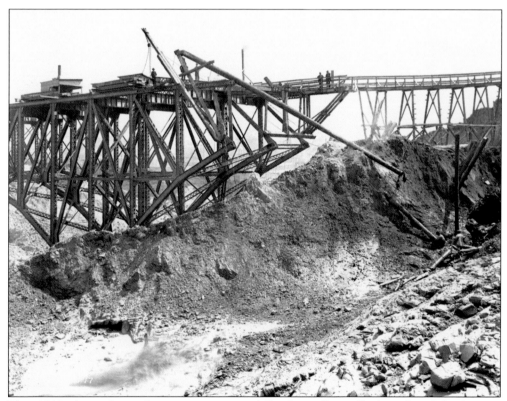

This 1917 photo shows the reconstruction of Dearborn Street Bridge after slide damage. (Seattle Municipal Archives 1387.)

This is a 1923 view of Spokane Street going over the hill from west to east. (MOHAI 7177.)

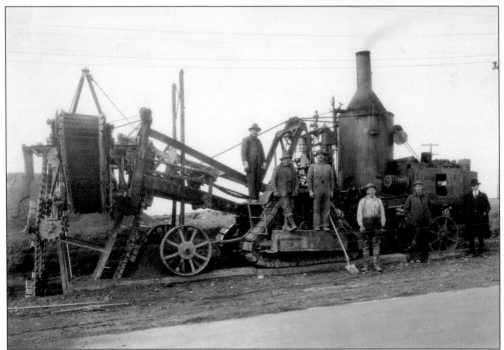

A 1923 photo shows the machinery that was used to construct the water lines running under Beacon Avenue. (MOHAI 7231.)

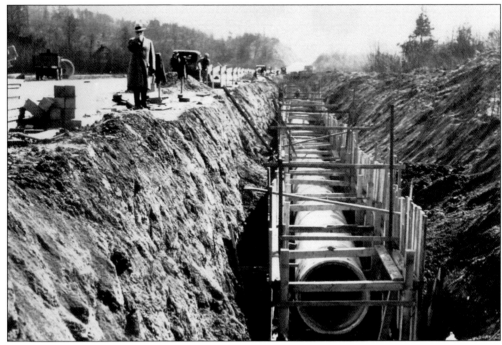

Water pipes were laid under Beacon Avenue in 1923. (MOHAI 7290.)

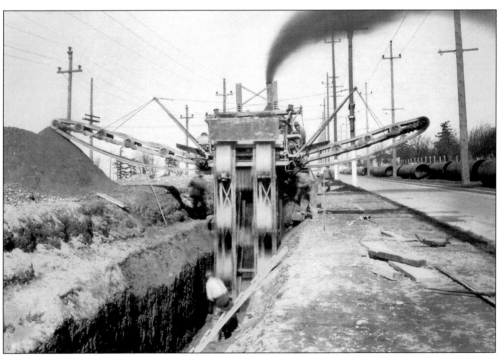

In this 1923 action shot, machinery is used to dig the trenches for the water pipes under Beacon Avenue. (MOHAI 7223.)

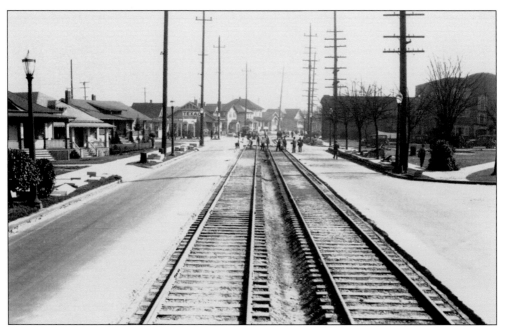

This is a 1934 view of trolley track work on Beacon Avenue near Stevens Triangle. (Seattle Municipal Archives 8678.)

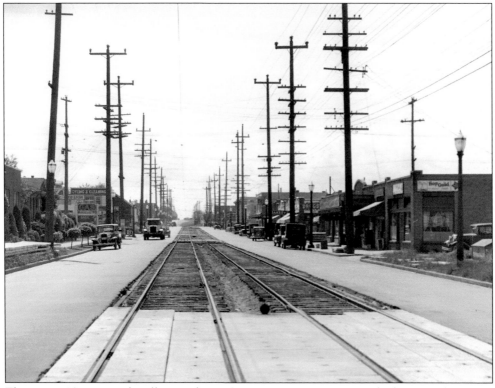

This is a 1934 view of trolley tracks on Beacon Avenue near Hanford Street. (MOHAI 1986.5.12270.)

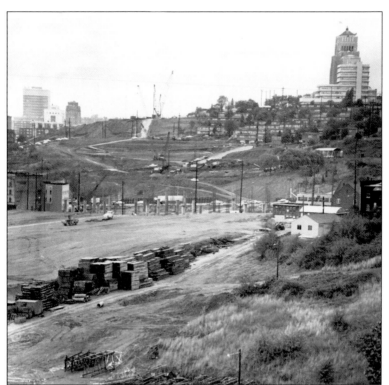

This 1962 image shows the construction of Interstate 5 freeway in 1962 near the north end of Beacon Hill with the Marine Hospital in view. (MOHAI 86.5.4041.)

This 1962 aerial view shows the construction of the Columbian Way exit of Interstate 5. (MOHAI 86.4065.1.)

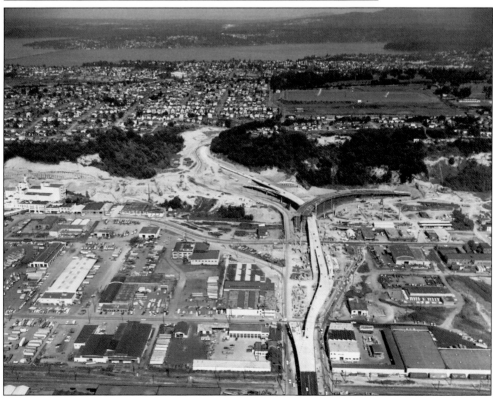

Two

Business on Beacon Hill

Everybody worked at the store. I remember when I was about six years old, I would be careful when I came down here because my dad's sisters would grab a hold of me and make me stock shelves.

—Bill DeVos

Establishment of the Beacon Hill street car line stimulated residential and business development in the early part of the century. Various types of businesses and services served the residents of Beacon Hill because most people did not own a car. The area where Fourteenth, Fifteenth, and Beacon Avenues come together was known as the "Junction," and was the center of the Beacon Hill business community. Pete Caso was born in 1923 and remembers the businesses on Beacon Hill.

The Beacon Hill theater was called the Gray Goose Theater. That was the original name. The Beacon Hill Market used to be a Piggly Wiggly store and next door to that was the 10¢ store and the hardware store. Across the street were Marvin's Bakery, Sether's Drug, and Molly's Cafe. Across the street from the Shell station was the Lamppost Tavern. That was there when I was young. The original Lamppost Tavern was on the west side, a little log cabin, it looked like. Later they moved over to the east side, across the street. There was Carl Nelson's ice cream store, the Beacon Ice Creamery. All the Beacon Hill athletes worked there.

According to Don Duncan the other business center was at Beacon Avenue South and South Hanford Street.

The other junction was known as Hanford Street. That was where we had a pharmacy with real soda jerks and magazine racks with Time *and* Life Magazine *and all the big movie magazines, none of which we ever bought. Right across from there was the Three Brothers Dye Works, run by the Endress family. They all went to Franklin High School and they were big, tall, gentlemen. Their motto on the sides of their trucks was "We Dye to Live." The Hanford Street Tavern was right across the street from that and there was the barbershop and Bruno's Shoe Repair. Dr. Horn, the dentist, was around the corner behind the pharmacy. It was $3 for a filling. That was too much for us really.*

Don Duncan remembers the businesses near the Beacon Hill School on Sixteenth Avenue South and Lander Street.

Right across from Old Beacon Hill School was Mr. Ellis's Cycle Shop. We would bring our bikes in because we were always getting our spokes bent. He would straighten our spokes and do things for us. He was a very kindly man. He smoked a pipe and was very grandfatherly. Right across from the school

(and I think this was the case at every school) there was a beanery. It was primarily kid's stuff. They had pop, although I never could afford that. You could go over there at noontime and get little things that you chewed, wax that had a fluid in them, little jugs. You could get bubblegum, sandwiches, and jawbreakers, very large candies in different colors. I think if you swallowed one you could choke to death. You could get Popsicles and the rumor was that if one said "free" on it, you could get a Schwinn bicycle. A friend of mine who had a wood burning set wrote the word "free" on one and took it in there.

Some businesses on Beacon Hill served a larger community. The Three Brother's Dye Works was the largest rug cleaners in the city. The pie factory owned by the Wickman family was a large operation that had 15 to 20 cooks and sold pies all over Puget Sound from Puyallup to Everett. After World War II the Beacon Hill business district declined. Pete Caso comments,

There were many businesses before and now there's absolutely nothing. There were four drugstores on Beacon Hill, three bakeries, five grocery stores, and all your daily shopping was done on Beacon Hill. Why did the businesses close? The businesses were there in the 1940s. They closed up after World War II, with supermalls and everybody got a car. Before those days, nobody had a car. Up until then you used the streetcar or you walked.

When Ron Chew grew up on Beacon Hill in the 1950s, he remembered very few businesses.

I never really viewed it as a 'business district.' You had the Beacon Hill Market and the public library, and you had Owens Pharmacy, Ogashima Insurance, and South China Restaurant, the golf course, and Jefferson Community Center and that was about it. There were some small businesses near the library and the shoe repair. There were other little businesses that would come and go.

When the Chinese community on Beacon Hill increased after WWII, the number of Chinese-owned businesses also increased. The United Savings and Loan, a Chinese bank, started out in the International District. The second branch opened on Beacon Hill in the '70s in recognition of the changing demographic patterns of the Chinese community. Frank Lioe started his successful automotive repair business on Beacon Hill in 1990.

One of the first Chinese entrepreneurs on Beacon Hill after WWII was Hing Lee, a first generation Chinese immigrant from Southern China. Mr. Lee opened the Shanghai Express grocery near the corner of Beacon Avenue and McClellan Street in the late '40s. Later Mr. Lee expanded his enterprise to create the South China Cafe. Rudy Simone, an Italian neighbor and construction contractor, built the new restaurant for Mr. Lee. The first cook, Jimmie Chin, lived in an apartment over the top of a building which formerly housed a laundromat on the corner of McClellan and Beacon. In the late 1950s the grocery store was closed and remodeled to become the main entrance to the restaurant. In the mid 1960s the family home to the north was remodeled and added onto the restaurant to serve first as a banquet room and later as a bar called the Dragon Room. By this time, around 1968, Hing Lee owned two homes behind the restaurant and his large family lived in both with the boys in one house and the girls in the other. All the kids in the Lee family worked at the restaurant as they were growing up. According to daughter Sharon Lee, she and her sisters did not participate in a lot of extracurricular activities after school because they were always at the restaurant. They would do their homework in the first booth inside the door as they tended the entrance and cash register. Hing Lee died in 1972 and in 1979 the Lee family turned over operation of the South China Cafe to Perry Ko.

Chinese dentists and doctors also began to open their practices on Beacon Hill as the residential base increased. Dr. Roy Mar, uncle of former city council member Cheryl Chow, has had a dentistry business on Beacon Hill for over 40 years. Dr. Mar has been an active member of the community. He helped Cheryl coach the first girls' basketball teams under the auspices of the Seattle Chinese Athletic Association in the '70s.

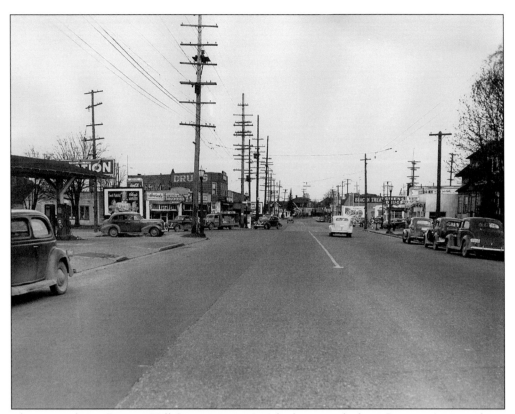

This view shows Beacon Hill Junction in 1946 looking north from Beacon Avenue down Fourteenth Avenue. The Beacon Hill Theatre is on the right side, and the Beacon Hill Barber shop is the small building at the turn in the road. (*Seattle Times.*)

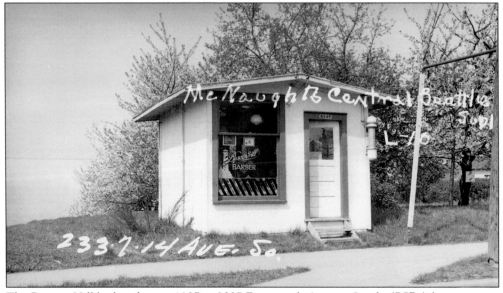

The Beacon Hill barber shop in 1937 at 2337 Fourteenth Avenue South. (PSRA.)

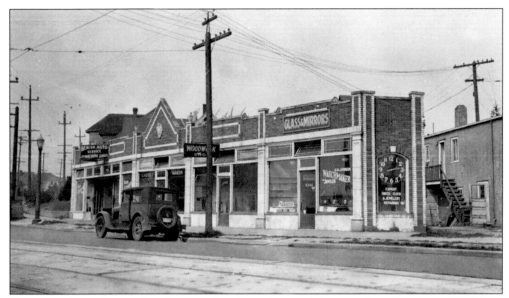

This view shows the watchmaker, woodworking shop, and Beacon Auto Service at 2336 Beacon Avenue South in 1937. Today this building is home to Lioe's Auto Repair and Java Love Coffee Shop. (PSRA.)

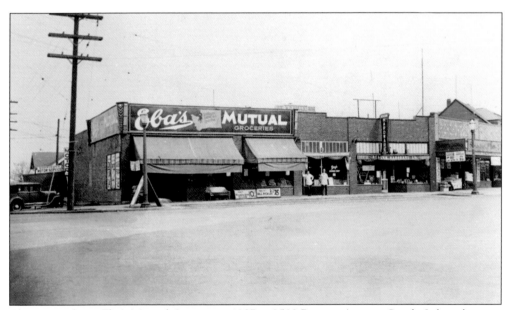

This image shows Eba's Mutual Grocery in 1937 at 2502 Beacon Avenue South. It later became the Piggly Wiggly, and today it is the Beacon Hill Market. The photo shows Ray's Barbershop, the hardware store, and Safeway grocery on far right. (PSRA.)

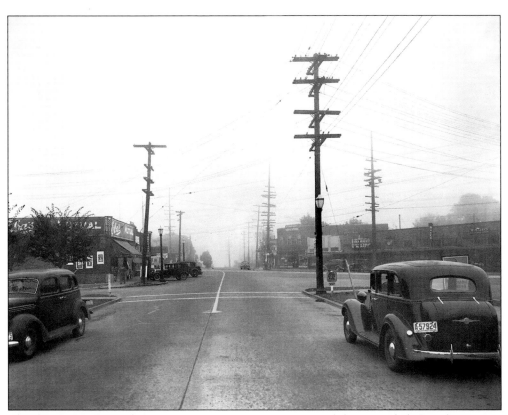

This foggy view shows the Beacon Avenue Junction, *c.* 1930. (El Centro de la Raza.)

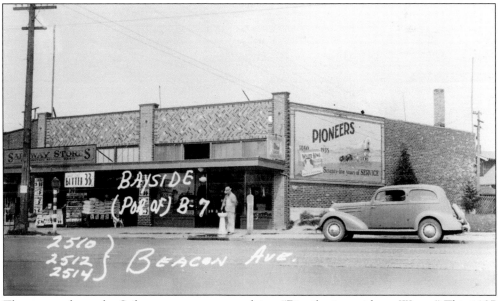

The motto above the Safeway store entrance claims "Distribution without Waste." This 1937 photo also shows the Beacon Hill Shoe Hospital at 2510 Beacon Avenue South. (PSRA.)

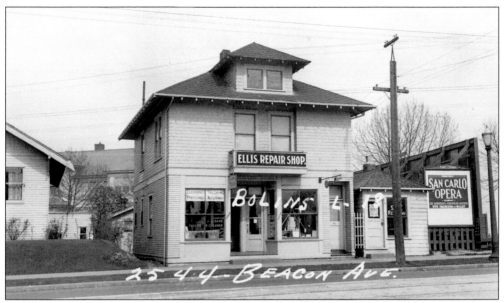

This 1937 photo shows the Ellis Repair Shop at 2544 Beacon Avenue south. The building behind the shop is the Beacon Hill school. (PSRA.)

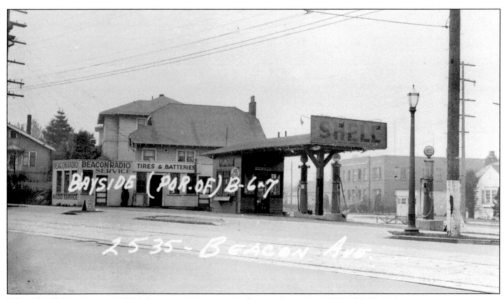

The Shell Station at 2535 Beacon Avenue is shown here in 1937. (PSRA.)

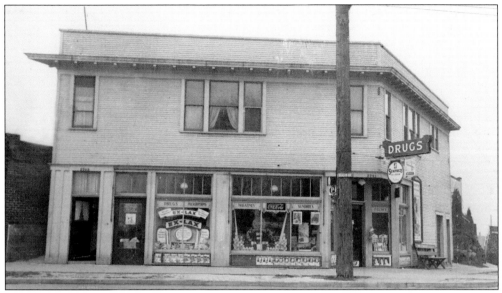

This 1937 photo shows the drugstore at 2701 Beacon Avenue. (PSRA.)

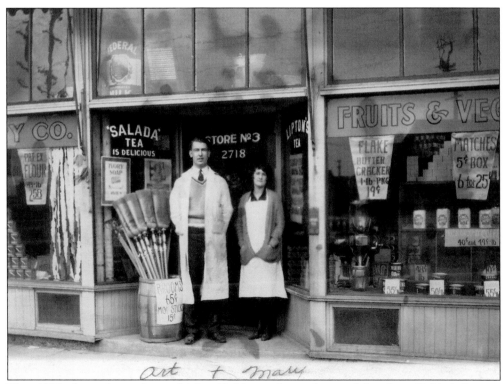

This 1920 photo shows Art and Mary DeVos in front of one of the three DeVos' Grocery Stores. This one, Store No. 3, was located at 2718 Beacon Avenue South where South China Restaurant is today. (DeVos family.)

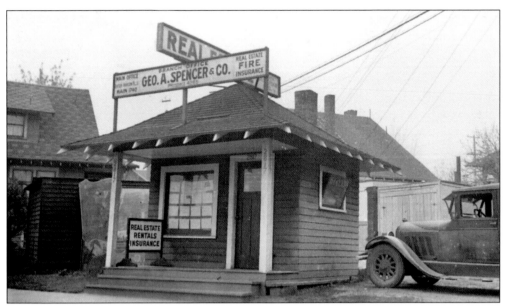

This image shows George Spencer Real Estate and Insurance at 2817 Beacon Avenue South in 1937. (PSRA.)

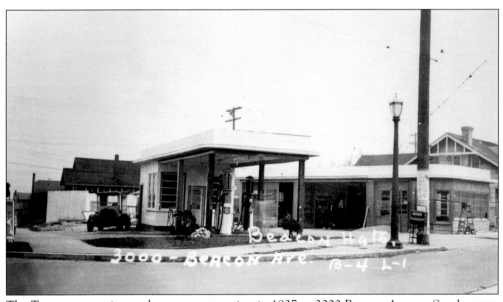

The Texaco gas station undergoes construction in 1937 at 3000 Beacon Avenue South across from Steven's Triangle. (PSRA.)

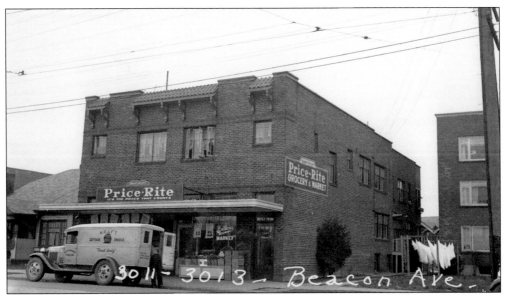

A 1937 photo of the Price Rite Grocery at 3011 Beacon Avenue South. (PSRA.)

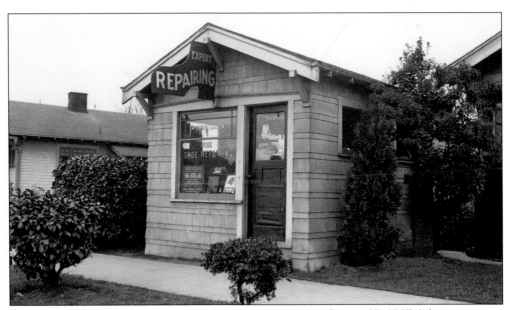

This view is of the Shoe Repair at 3033 Beacon Avenue South in 1937. (PSRA.)

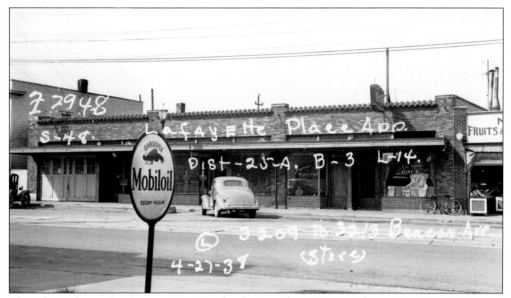

This photo shows the Beacon Dry Goods, the Josephine Beauty Shop, Mrs. Maas Café, and Nick's Fruits and Vegetables at 3209 Beacon Avenue South in 1937. (PSRA.)

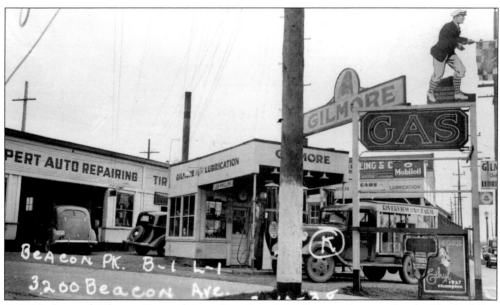

A 1937 photo of Gilmore Gas and Auto Repair at 3200 Beacon Avenue South. The building behind the gas station is the Three Brothers Dye and Cleaners. (PSRA.)

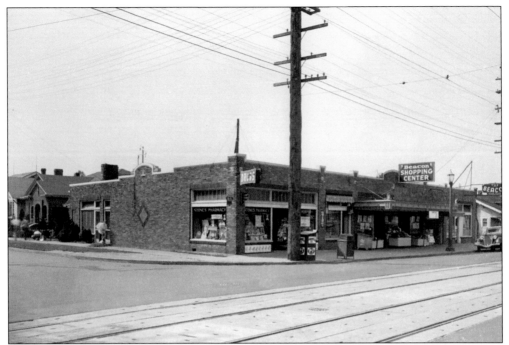

This 1937 view shows the Beacon Shopping Center, Stone's Pharmacy, Eva's Beauty Shop, and the Beacon Tavern at 3057 Beacon Avenue South. The brick building that houses these businesses was built in 1926. (PSRA.)

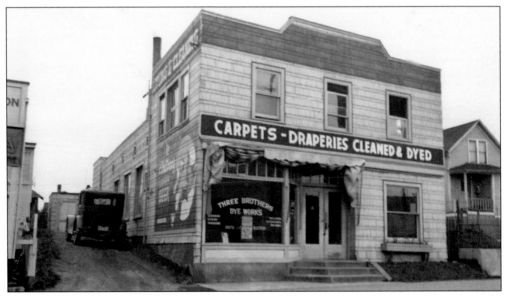

This is a 1937 photo of the Three Brothers Dye and Cleaners at 3210 Beacon Avenue South, whose motto was "We Dye to Live." (PSRA.)

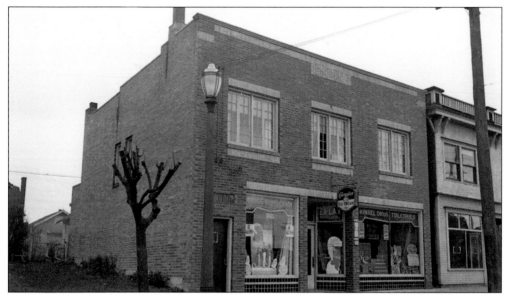

The Kinsel Drugs at 3318 Beacon Avenue South is shown here in 1937. This building was constructed in 1930 and is currently home to Day Moon Press. (PSRA.)

The Toyo Grocery at 2122 Fourteenth Avenue South is today the site of the Asian Express grocery. It was built in 1928 and shown here in 1937. Note the arrangement of food in front window typical of Japanese groceries. (PSRA.)

Three

EAST MEETS WEST

We didn't play tennis and my son went up to Jefferson Park to find somebody to play with. I said, "You'll find somebody, just go up there." There was this little Asian girl who beat the pants off him. It was Amy Yee of course! Little did he know. He came back and said, "Boy, she was good!"

—Marge Haralson

From the turn of the century until about 1943 the population of Asians, and, for that matter, any people of color on Beacon Hill, was scattered at most. There were a few Japanese and Black families. There were very few Chinese families on the hill before World War II. Frank Miyamoto was born to immigrant Japanese parents around 1913 and he moved to Beacon Hill in 1919, in the second grade.

My father came with the idea of staying permanently in this country, which was not characteristic of most of the Issei (immigrant) parents of that time. When I was in second grade, he decided that we should move out of the Japanese community towards Beacon Hill. At that time, Beacon Hill was almost totally white middle-class, lower-middle class whites, and there were perhaps two other Japanese families living on the Hill. Once we moved in, rowdies, vandals, would make it unpleasant for us by throwing junk on our front porch and this sort of thing. Others accepted us in the sense of not bothering us in any way.

When the Japanese community was faced with internment and had to hastily put their businesses and lives in storage, many neighbors were sympathetic and helpful.

Italian-American Joe Forte was born in 1919 and grew up on Sturgis Avenue. He remembers when the Japanese were interned.

We had several Japanese families in our area. Our next door neighbors were Japanese. They went to Colman School. When we had a grade school reunion, one of the brothers was still alive. One family I remember, they had a pharmacy on Jackson Street and they lived next door to the Beacon Hill clubhouse, the garden club. My sister Mary and her husband lived in back of them. When they were going to be sent to the internment camp, they gave my sister a trunk to keep for them. They all had to meet with their suitcases on the corner right in front of our house. My mother cried, "What did they do? They didn't do anything." She thought it was wrong to do that. They had to sell everything for nothing.

Just two years after the Japanese were interned the 60-year-old Chinese Exclusion Act was lifted, paving the way for new immigrant Chinese families to enter the United States. Up until this time the Chinese community was comprised primarily of single working men living in the rooming apartments in Chinatown/International District. The center of the Chinese

community had always been near Beacon Hill, in the areas around Ninth and Jackson Street. It was a natural move for new Chinese families to seek larger homes on Beacon Hill, which was just up the hill and across the Twelfth Street Bridge. It probably helped that there had always been good bus service to Beacon Hill from downtown and Chinatown. Due to housing discrimination there were not very many neighborhoods where people of color could easily buy homes in the 1940s, 1950s, and even the 1960s.

Lee Hamre was born in 1932 and worked in real estate for 47 years. His father, E.A. Hamre, started the real estate office on Beacon Hill, located next to South China Restaurant on Beacon Avenue. According to Lee, the discriminatory policies of the real estate establishment were much to blame for the difficulties minorities had in finding housing in the '40s, '50s, and '60s. The unspoken policy was not to sell houses to minority residents in neighborhoods where they did not already reside. He remembers that there was tremendous animosity after World War II towards the Japanese. "There was a judge listing his house on the hill, but he wouldn't sell to a Japanese buyer. The restrictive covenants against people of color were still coming up in the deeds. We helped a lot of Japanese families buy homes on the hill after the war."

The real estate policy was sometimes circumvented by arrangements with neighbors or friends, some of whom may have encountered housing discrimination at times themselves. Archives of the Black Heritage Society of Washington State tell the story of Nellie Carter, a widow and grandmother, who in the 1950s watched a two-bedroom brick home being built on Beacon Hill at Twenty-third and Spokane Street. She decided she wanted to buy that home. Knowing that she would be unable to buy it herself as a Black woman, she arranged with a Japanese-American business acquaintance to purchase it for her. Mr. Kay Yamaguchi assisted her in the purchase. After Mr. Yamaguchi purchased the home from J.B. and Mary Jessen for $16,800, he arranged a real estate contract with Mrs. Carter and signed a quitclaim deed on May 1, 1954, to turn the home over to her.

Like minority communities before them, Vietnamese families were introduced to Beacon Hill by establishing connections with surrounding areas. Chinatown grocery stores and social service agencies were one source of support for the new immigrants, who arrived in waves in the late 1970s and early 1980s. Some refugee families moved into low-income housing at Rainier Vista and Holly Park. Slowly the community began to gather and develop. Grocery stores with Vietnamese food, traditional tailoring, and other businesses started first in people's homes. Vietnamese groceries, restaurants, travel agencies, jewelry stores, and hair salons were eventually established at the corner of Jackson and Twelfth, just across the Jose Rizal Bridge from Beacon Hill. This bustling business area is now called "Little Saigon."

According to Roberto Maestas, director of El Centro de la Raza, the immigrant mix on Beacon Hill is one of the neighborhoods greatest strengths.

> When I first came to Beacon Hill, there were probably White Ethnics and Asians living here almost entirely. In the last two, three decades, Beacon Hill has become a crossroads of the world. I bump into people from the Middle East, from every corner of the globe, from Africa, Asia, Latin America, the Caribbean. It has become a reflection of the world-wide demographic patterns of people migrating to the United States. The immigrant presence in the last several decades has influenced the make-up of Beacon Hill in a beautiful, positive way.

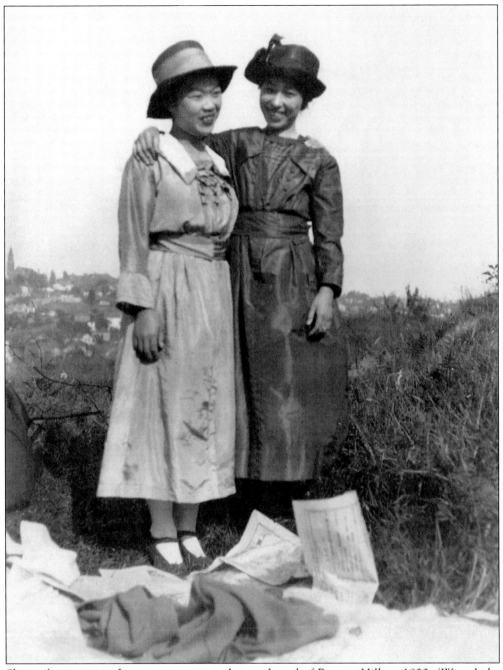

Shown here are two Japanese women at the north end of Beacon Hill, c. 1920. (Wing Luke Museum Sese Makino Collection 1999.098.234.)

The Genshiro Noji Florist Shop at 3206 Juneau Street is shown here c. 1922. (UW 11335.)

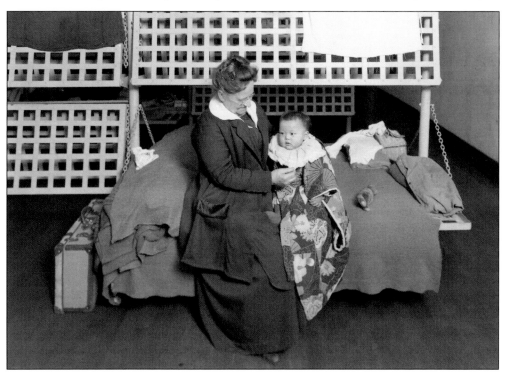

An immigration official at the immigration detention facility cares for a Japanese baby whose mother was not given entry into the United States, c. 1924. (MOHAI 83.10.1969.)

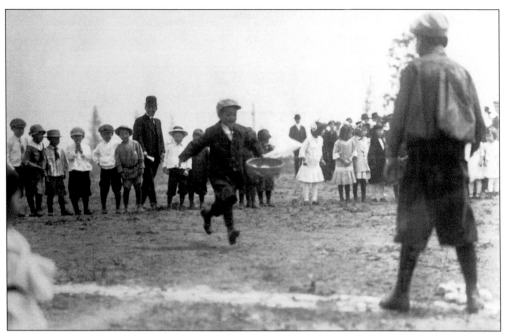

The boys' basket race at a Japanese-American picnic is shown here. From the 1920s until 1941 the Japanese language school held picnics in Jefferson Park on Beacon Hill. These c. 1920 photos of the picnics are believed to have been taken in Jefferson Park. (DENSHO.)

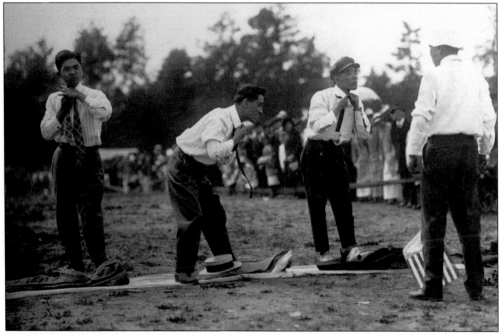

This photo shows the adult relay race at a Japanese-American picnic, c. 1920. The men race to the center line, put on a traditional kimono costume, race to the end line and then back to the center line. As shown here, they then remove the traditional costume, put on a modern hat and tie, and then run to the finish line. (DENSHO.)

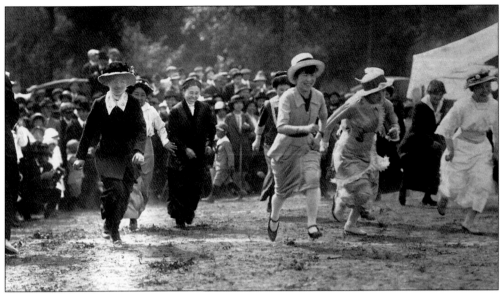

Shown here is the ladies footrace at a Japanese-American picnic, c. 1920. (DENSHO.)

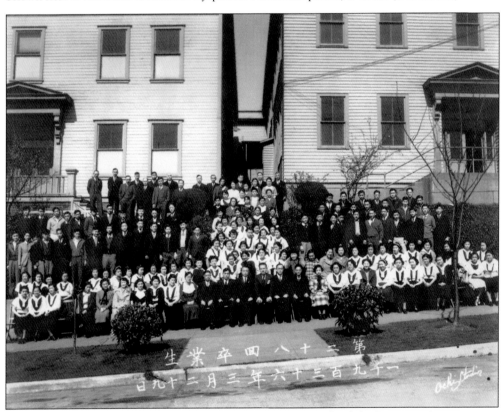

This photo shows students of the Kokugo Gakko Language School for Japanese-Americans on Fourteenth and Weller in 1935. Almost all Japanese immigrant families sent their children here to study Japanese language and culture. The language school organized the spring picnics in Jefferson Park. (MSCUA UW 11536.)

WESTERN DEFENSE COMMAND AND FOURTH ARMY
WARTIME CIVIL CONTROL ADMINISTRATION

Presidio of San Francisco, California
May 15, 1942

INSTRUCTIONS
TO ALL PERSONS OF

JAPANESE

ANCESTRY

Living in the Following Area:

All of that portion of the County of King, State of Washington, within the boundary beginning at the point at which the Snohomish-King County line meets Puget Sound; thence easterly and following said county line to the western limits of the Snoqualmie National Forest; thence southerly and following the limits of said National Forest to the Middle Fork of the Snoqualmie River; thence westerly and following the Middle Fork of the Snoqualmie River, and the Snoqualmie River to its intersection with U. S. Highway No. 10 at Fall City; thence westerly along said Highway No. 10 crossing Lake Washington Floating Bridge to the west line of Lake Washington; thence northerly along the west line of Lake Washington to East 85th Street extended; thence westerly along East 85th Street extended and 85th Street to Puget Sound; thence northerly and following the shoreline of Puget Sound to the point of beginning.

Pursuant to the provisions of Civilian Exclusion Order No. 80, this Headquarters, dated May 15, 1942, all persons of Japanese ancestry, both alien and non-alien, will be evacuated from the above area by 12 o'clock noon, P. W. T., Wednesday, May 20, 1942.

No Japanese person will be permitted to move into, or out of, the above area after 12 o'clock noon, P. W. T., Friday, May 15, 1942, without obtaining special permission from the representative of the Commanding General, Northwestern Sector, at the Civil Control Station located at:

122 Kirkland Avenue,
Kirkland, Washington.

Such permits will only be granted for the purpose of uniting members of a family, or in cases of grave emergency.
The Civil Control Station is equipped to assist the Japanese population affected by this evacuation in the following ways:

1. Give advice and instructions on the evacuation.
2. Provide services with respect to the management, leasing, sale, storage or other disposition of most kinds of property, such as real estate, business and professional equipment, household goods, boats, automobiles and livestock.
3. Provide temporary residence elsewhere for all Japanese in family groups.
4. Transport persons and a limited amount of clothing and equipment to their new residence.

The Following Instructions Must Be Observed:

1. A responsible member of each family, preferably the head of the family, or the person in whose name most of the property is held, and each individual living alone, will report to the Civil Control Station to receive further instructions. This must be done between 8:00 A. M. and 5:00 P. M. on Saturday, May 16, 1942, or between 8:00 A. M. and 5:00 P. M. on Sunday, May 17, 1942.
2. Evacuees must carry with them on departure for the Assembly Center, the following property:
 (a) Bedding and linens (no mattress) for each member of the family;
 (b) Toilet articles for each member of the family;
 (c) Extra clothing for each member of the family;
 (d) Essential personal effects for each member of the family.
All items carried will be securely packaged, tied and plainly marked with the name of the owner and numbered in accordance with instructions obtained at the Civil Control Station. The size and number of packages is limited to that which can be carried by the individual or family group.
3. No pets of any kind will be permitted.
4. No personal items and no household goods will be shipped to the Assembly Center.
5. The United States Government through its agencies will provide for the storage, at the sole risk of the owner, of the more substantial household items, such as iceboxes, washing machines, pianos and other heavy furniture. Cooking utensils and other small items will be accepted for storage if crated, packed and plainly marked with the name and address of the owner. Only one name and address will be used by a given family.
6. Each family, and individual living alone, will be furnished transportation to the Assembly Center. Private means of transportation will not be utilized. All instructions pertaining to the movement will be obtained at the Civil Control Station.

Go to the Civil Control Station between the hours of 8:00 A. M. and 5:00 P. M., Saturday, May 16, 1942, or between the hours of 8:00 A. M. and 5:00 P. M., Sunday, May 17, 1942, to receive further instructions.

J. L. DeWITT
Lieutenant General, U. S. Army
Commanding

SEE CIVILIAN EXCLUSION ORDER NO. 80

On May 15, General Dewitt executed the 1942 Exclusion Order, commanding all persons of Japanese ancestry to vacate the West Coast of the United States. (UW 11368.)

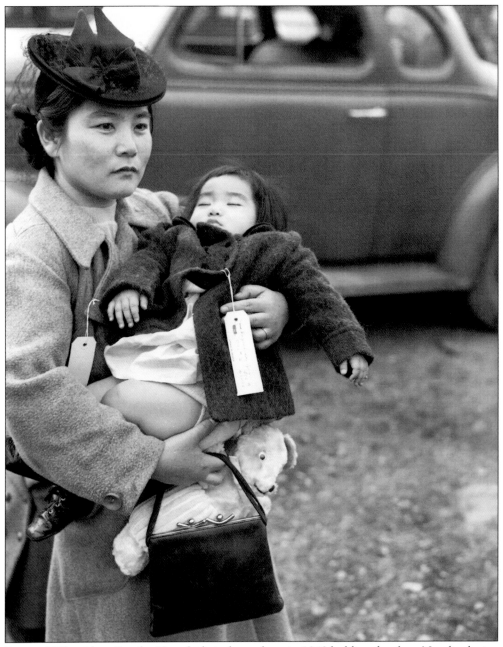

Beacon Hill resident Fumiko Hayashida is shown here in 1942 holding daughter Natalie during the Japanese-American evacuation from Bainbridge Island. After the internment, she moved to Beacon Hill in Seattle. (MOHAI PI-28050.)

Former City Council member Cheryl Chow, shown here at age five in 1952, gets an escort from Seattle police as the mascot for the Chinese Drill Team organized by her mother Ruby Chow. (MOHAI PI-22413.)

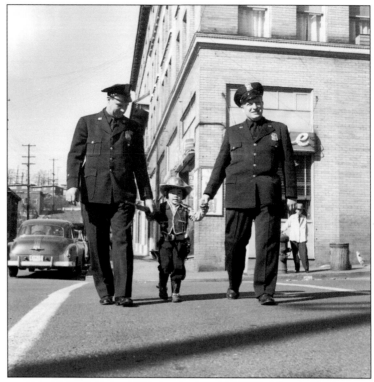

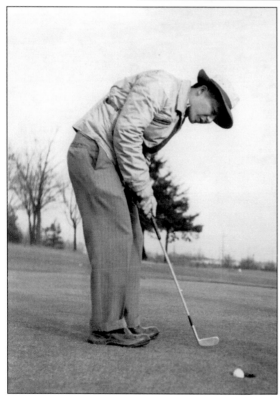

In the 1940s and 1950s, African-Americans, Japanese-Americans, and Chinese-Americans organized their own golf clubs in response to exclusionary practices of white clubs, to socialize and to educate youth in the sport of golf. Hing Chinn, a member of the Chinese Cascade Golf Club, is shown here in 1953, golfing at Jefferson Park. (Hing Chinn.)

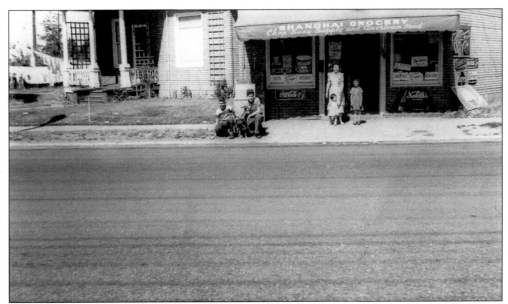

Sharon Lee, older sister Denise, and mother Ting Chinn Lee are shown here in 1954 at the Shanghai Grocery. The "Chop Suey Supply and American Food" grocery was run by the Hing Lee family, next door to their first house at left. Later the store was remodeled to become the entrance and booth section for the South China Restaurant started by Hing Lee and family. (Lee family.)

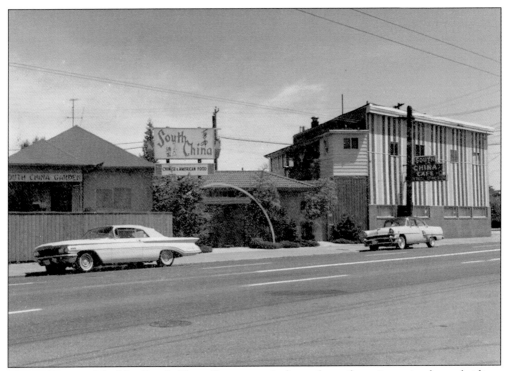

The 1960s remodel of the South China Restaurant is shown here, featuring striped metal siding, the Garden Room (where the Lee's first house was), and the main entrance where the former grocery store stood. (Lee family.)

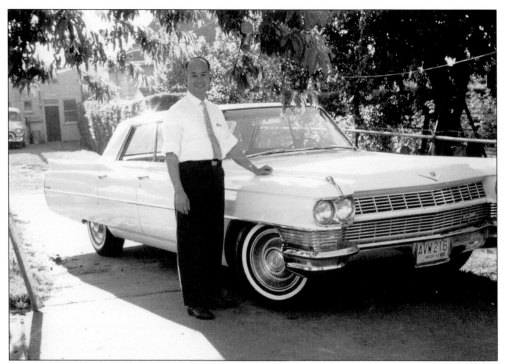

Hing Lee, founder of the South China Restaurant is shown here with a new 1964 Cadillac. (Lee family.)

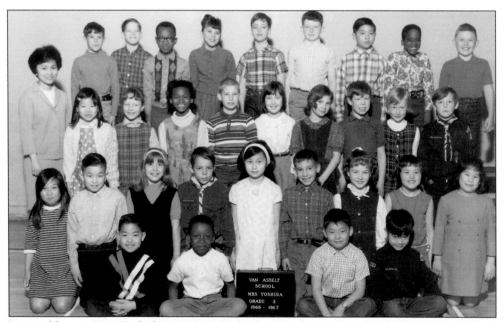

Pictured here is Mrs. Yoshida's 1966–1967 third-grade class at Van Asselt Elementary School on South Beacon Hill. By the 1960s, Beacon was an extremely diverse neighborhood of Chinese, Japanese, African-American, Filipino, and European-American families. (Seattle Public Schools 275-7.)

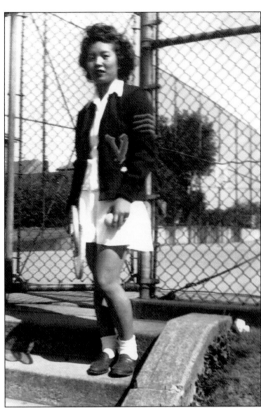

This photo of tennis champion Amy Yee was taken in the early 1940s at the tennis court at Jefferson Park. Amy Yee coached children and youth on Beacon Hill for many years. (Yee family.)

Amy Yee is shown here giving "tiny tots" tennis lessons. (Yee family.)

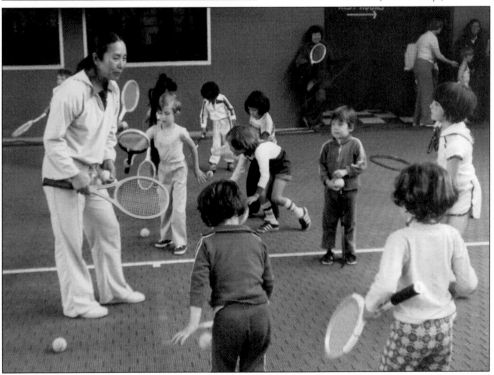

Four

SOUTH BEACON HILL

When we were kids we used to drive down and visit my half-uncle in Renton and there was nothing between here and Renton. It was so wooded and raw, with very few people that you used to have fog. You would go over to Renton earlier in the day or evening and the fog would come in and you couldn't even see the road coming back home from Renton.

—Tom Rockey

Tom Rockey was born in 1928 at 4722 South Bond Street at home on the farm. At that time South Beacon Hill was a rural setting. Tom was close friends with neighbor Gloria Sferia and her family. Gloria's family bred race horses and their 25-acre horse farm still nestles in the southern portion of Beacon Hill off Bond Street. It is the last working horse farm in the city.

I always liked horses. Our neighbor across Bond Street had a little old horse called Rusty. You couldn't catch that horse unless you ran up behind him and jumped on his back. Once you got on him he was all right, he would stand and do what you wanted him to do. He wouldn't let you catch him; he was running all over that pasture. That was my first experience with horses. And then Gloria's family has always been into horses and they were racing and she was the person who got me into racing. When I was a young kid I used to ride my bike out to Longacres and work in the stalls, just to be near the horses. I was a farm boy and I knew how to work in and around horses so I was down there for several years and I used to go to the races all the time. We had a group of friends who were all race nuts. They would pay us to clean stalls, not much, a pittance.

Basically we were farmers and we planted a big vegetable garden and had fruit trees all over the place and during the early part of the war we were raising chickens. We had laying hens and fryers. Mom worked her butt off like a slave, we all did. Dad was out peddling eggs at the stores. Pretty much every weekend we would take a trip through the Italian community taking eggs and poultry and rabbits out there. All that community used to buy food from us. Dad had a route that he ran and it was all friends of the family. I used to go along and do the grunt work, dish up the eggs and get the right piece of meat. Dad's first vehicle was a 1927 Dodge that had been converted to a touring car. It had a different gear shift than today's vehicles. It was black as I remember it. It had the back part of the body removed. I think he bought it that way. I learned how to drive on that vehicle.

We always sold the poultry for money, no bartering. We had a whole row of chicken houses down behind the house. The first one was a real oldie and then we built another one. These were long, two-story buildings. We built the chicken houses with the Brandlioses (neighbors). Tony was about seven years older than I and he probably remembers pounding nails with me as a kid. So we had four coops of laying hens and then dad wanted to get into raising fryers. We were raising fryers and killing fryers and selling to Rosies' Roadhouse down on Highway 99. And during the war, every weekend we were selling fryers and killing them and cleaning them. Pretty much the whole family butchered the chickens, we had about four or five of us around the table plucking chickens.

53

Bob Griffin was born in 1924 and grew up on South Beacon Hill at 1429 South Cloverdale.

> In the early years on Beacon Hill, as you can well imagine, we were kind of out on the end of the
> hill. There wasn't anywhere near the traffic flow. All the way down to the airport was woods.
> It was all open. We were in a little area all by ourselves as far as the kids playing, because there
> wasn't really anyone north of us clear to past Cloverdale really. There weren't many activities
> up here, there was no clubhouse or anything, so we used to go down to Pritchard Beach, before
> it became an official swimming beach. There was no bathhouse or floats and then we would ride
> our bikes all the way down to Seward Beach. Eventually they put in Pritchard Beach bathhouse.
> Where the Aloha Market is now, to the south used to be a little small gas station owned by the
> Andersons. We used to go up to the gas station and they had the typical old pump where you could
> crank the gas up and you could see it in the circular glass. So a guy would want five gallons of
> gas and the Mr. Anderson would let us pump the thing up and we would watch it until it got five
> gallons in there. That was a focal point in the area.

Both Bob Griffin and Tom Rockey hung around Boeing Field as kids. Boeing field is located
just west of the southern end of Beacon Hill. Joe Desimone, an Italian farmer donated the
land for the construction of the Boeing Airplane Company. Boeing has been a major source
of employment for south end residents since the 1940s. Bob Griffin remembers visiting the
mechanics at Boeing both before and during WWII.

> During the summertime, we would leave the house here and we would run three telephone poles length
> and walk one. And run three telephone poles and walk one and then we would go down over the hill
> to Boeing field. At that time, before the war, there were no fences. You could walk all over Boeing
> field and go in the hangars. We got to know a couple of guys who were working on the planes and we
> would go in a help them do this and that. They were putting the fabric on the planes. I think we could
> have become dope addicts without knowing it with all the glue and stuff. I bet we went down to Boeing
> Field probably four days a week. That was our routine. Go down to Boeing Field, go back home, have
> a sandwich and go down to Lake Washington and go swimming.
>
> During the war Boeing Field was all camouflaged. On the roof it looked like gardens, streets,
> and everything. All around here, in back of us, were the barrage balloons and anti-aircraft guns.
> So we used to go over there and talk to all the soldiers. So many of the soldiers, for whatever
> reason, were from the south. They all had these drawls and everything. Then the people around
> here, the moms, would bake the soldiers cakes and pies and we would take them over there and we
> were friends with all the soldiers on the anti-aircraft guns.

One of the most spectacular hidden gems of the South Beacon Hill area is Kubota Gardens, a
historical landmark and 20-acre park is located on Renton Avenue South. The city acquired the
property in 1987 from the estate of master landscaper Fujitaro Kubota. In 1927 Fujitaro Kubota
bought five acres of logged-off swampland and began his garden. A 1907 emigrant from the Japanese
island of Shikoku, he established the Kubota Gardening Company in 1923. He was self-taught as a
gardener and he wanted to display the beauty of the Northwest in a Japanese manner. He was soon
designing and installing gardens throughout the Seattle area. The gardens on the Seattle University
campus and the Japanese Garden at the Bloedel Reserve on Bainbridge Island are public examples
of his work. The gardens are a spectacular setting of hills and valleys, interlaced with streams,
waterfalls, ponds, bridges, and rock out-croppings with a rich array of plant material.

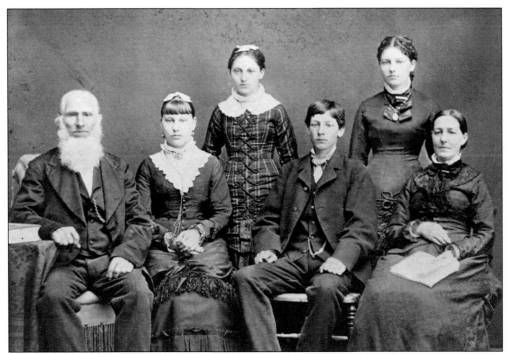

This photo from 1886 shows the Van Asselt family who were early settlers on south Beacon Hill. (MOHAI SHS 971.)

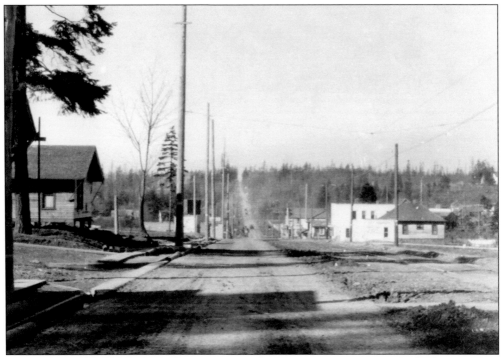

This images looks south on Beacon Avenue in 1910, possibly near Graham Street South. (MOHAI 1974.5868.238.)

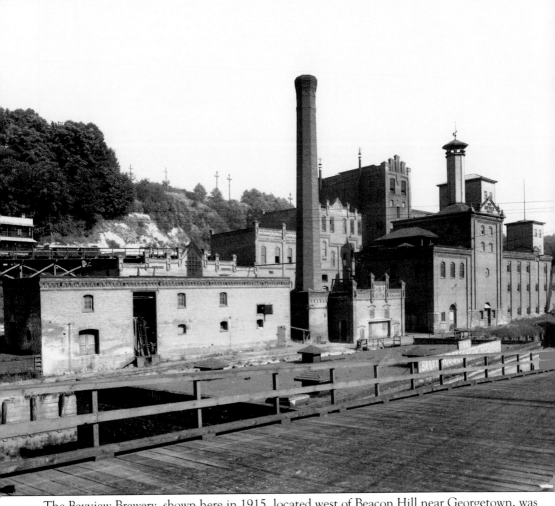

The Bayview Brewery, shown here in 1915, located west of Beacon Hill near Georgetown, was the predecessor to the Rainier Brewery. (MOHAI 83.10.1091.)

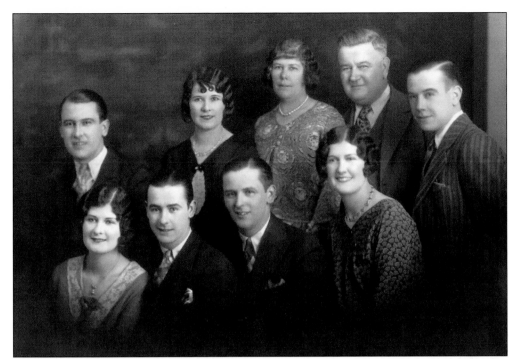

This 1929 family photo of the DeVos family shows from left to right (top) Art, Nettie, Mother Mathilde, and Father Louis; (bottom) Babe, James, Frank, Mary, and Charlie. (DeVos family.)

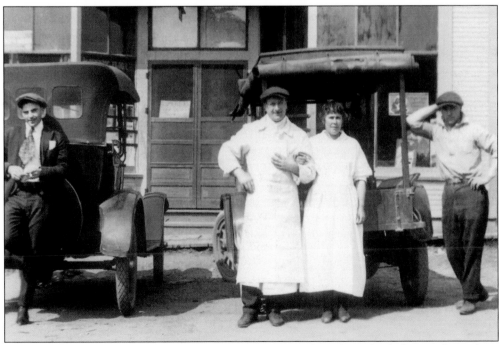

The first DeVos grocery store in 1917 on Thirteenth South and South Shelton is shown here with delivery trucks, the butcher, and Mathilde DeVos. Today, Bill DeVos, son of Art DeVos, still runs the grocery with his wife Gail. (DeVos family.)

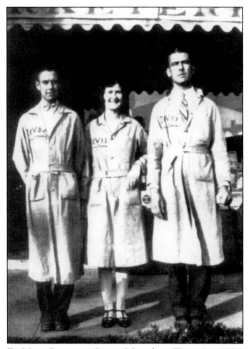

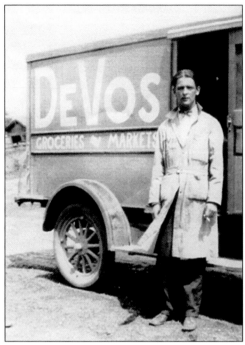

DeVos Grocery Store Number Two in 1920 on Orcas Street is shown here with Art, Mary, and Charlie DeVos. (DeVos family.)

Frank DeVos is shown here in 1920 with the DeVos Grocery delivery truck. (DeVos family.)

The DeVos family home on Thirteenth Avenue South is shown here c. 1930. (DeVos family.)

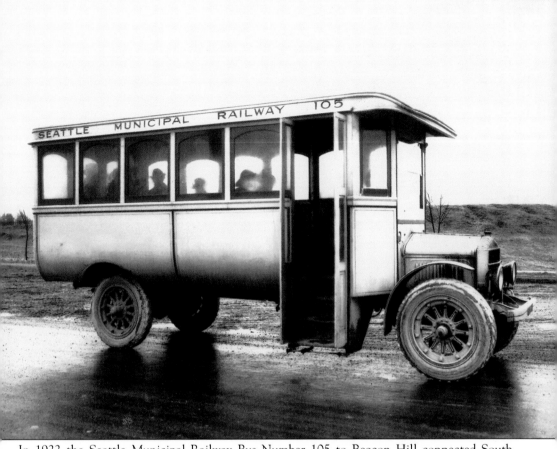

In 1922 the Seattle Municipal Railway Bus Number 105 to Beacon Hill connected South Beacon Hill residents to the trolley at the north end of the hill. (MSCUA UW SMR 160.)

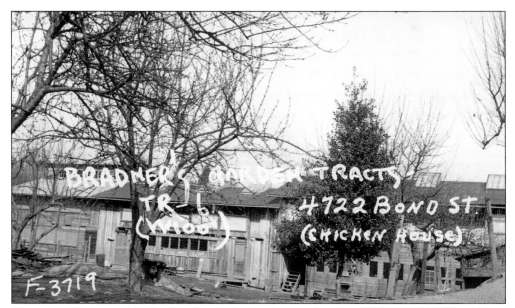

This is a 1937 photo of the Rockey family chicken houses that Tom Rockey and his friend Tony Brandiliose helped to construct. (PSRA.)

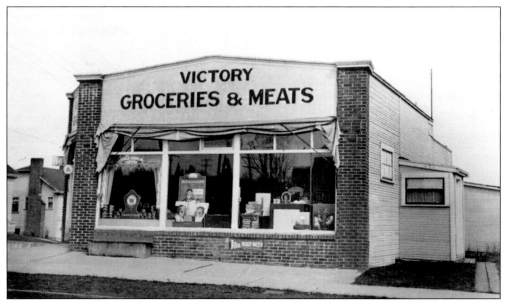

This is a 1937 photo of the Victory Market. Tom Rockey's father, Antonio, sold eggs to the Victory Market as well as to other local groceries and families in the Rainier Valley. (PSRA.)

An airplane from Boeing Field crashed into the Lester Apartments on southwest Beacon Hill in 1951. (MOHAI PI-20240.)

Italian farmer Joe Desimone received an award in 1942 from the Boeing Airplane Company for donating land for Boeing Field. (Festa Italiana P9080406.)

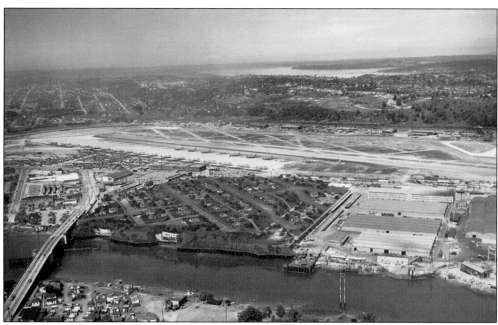

This 1943 view is of the Boeing airplane plant, west of Beacon Hill. During World War II artificial landscape covered the heart of the factory where the B-17s and B-29s were made. (Seattle Public School 012-133.)

Five

JEFFERSON PARK

We used to get a nickel a piece for shagging balls either down the gully or in the pond.
We would reach in the pond with our hands but later on they cemented the pond and you
could feel'em with your feet, in the mud. We ran around there barefoot all day anyway.
You could make enough money in two weeks for a new pair of cords, a new pair of shoes,
a couple of shorts, and get ready for school.

—Pete Caso

Beacon Hill's Jefferson Park is part of the citywide network of parks and boulevards designed for Seattle residents by the Olmsted Brothers Landscape firm. The sixth largest park in the city, Jefferson Park is located at an elevation of 340 feet and hosts spectacular views of the Olympic Mountains, Puget Sound, Seattle Downtown, and the Cascade mountain range. Jefferson Park has a rich cultural heritage and is a significant regional resource for south end neighborhoods as well as being the central recreational feature within the Beacon Hill community.

The park hosted the city's first municipal golf course. Opening in 1915, the historic 18-hole golf course on the east side of the park closely parallels what Olmsted envisioned for the park. Over the 90-year history of Jefferson Park the west side of the park has experienced significant change and reorganization. The park has housed a wide array of facilities and uses, some of which still exist and many of which are gone. Early on it was established as a site for hospital care, golf, recreation, and water reservoirs. These primary functions continue to exist. Facilities that no longer exist include the city prison, a poor peoples' farm, a World War II recreation facility for soldiers with a roller skating rink, historic community picnic grounds used primarily by the Japanese community, an English cricket pitch, and a fishing pond. It has also been a long time since neighbors on Fifteenth Avenue let their cows graze in the park, since the golf course was used to host a World War I air circus, or since horseback riding was enjoyed as a recreation experience in the park.

The City of Seattle paid $11,711 in 1898 for the 235-acre tract of land, intending to use it for a cemetery. The cemetery was never built at this site. A hospital for persons with contagious disease, also known as the "pest house," was built on the land in 1892 to house smallpox patients. In 1909, the city transferred 137 acres east of Beacon Avenue that were not being used for the reservoir and pipeline facilities to the Park Department. That same year the city established a stockade to house city jail inmates serving short sentences. Inmates worked off their sentences by clearing the land set aside for Jefferson Park. Among those who worked at the stockade were husbands who had abandoned their families, thus the facility was called the "Lazy Husbands Ranch." In 1914 a greenhouse and nursery was built at Sixteenth and Dakota. As late as 1917 those serving sentences at the prison were working at the prison farm and the nursery. The prisoners were used to clear the land for the construction of the first municipal golf course, which is now the 18-hole golf course at Jefferson. For a short period of time the daily work foreman from the parks department became the prison guard after the budget for the police guard ran out. This service was apparently provided in exchange for the use of the prisoners

as labor for the park. The guard arrangement was finally terminated, as it was contrary to civil service regulations.

The City Emergency Hospital was built in 1918 over the objections of the parks board, who did not want it sited near the golf courses. The hospital was to serve unwed pregnant women and patients with venereal disease. It was not considered a community friendly proposition. In order to close the deal the city exchanged the 40 acres that formerly housed the stockade (city prison) with one acre of land that would house the new hospital. The 40 acres went to the parks department and was later used to build the nine-hole golf course on the west side of the park. The membership of the Jefferson Park Ladies Improvement Club, who opposed the presence of the pest house and stockade in the park, were given permission to torch the facilities, which they did with gala celebration. In this fashion the southern boundary of the park was established and hospital services continued to be a part of the mix of facilities at Jefferson.

Pete Caso was born in 1923 and grew up caddying at Jefferson Park Golf Course

> We grew up in this clubhouse. I was maybe 8, 9 or 10 years old when we started up here. I have a caddy badge here that is older than you are. I got that badge in about 1936 or '37. It cost 50¢ deposit for that with the City of Seattle. You had to go to school one summer with the caddy master, Fred Collins, who lived upstairs in the clubhouse. He would have a little class during the summer time and you attended that class for about four or five days and then you were a first-class caddy and that entitled you to 75¢ a round. A second-class caddy got 65¢ a round.
>
> Mr Jefferson lived right near the old nine hole golf course. "Old Joe" we called him, was a wonderful guy. Scotsman, right from the old sod. He took care of us kids. He taught us all the golf etiquette. He gave lessons at the driving range out the back. We used to shag balls for the lessons. For a half hour lesson you would get 35¢ for shagging balls. We didn't have to wear uniforms, but you had to come clean. If you came up here dirty, they would send you home. I never got sent home. My mother would never let me out of the house without clean socks and underwear. She said, you might get taken to the hospital and there you would be with dirty socks or underwear.
>
> When we were caddying, we would rather caddy for an Asian than for a White guy 'cause the Asians always gave you a dollar. The Japanese always gave a good tip. There were Japanese up here golfing big time because the NYK Line was the old steamship line and it came into Seattle. They would bring many, many Japanese up here. There were the tourists but also Japanese business people. As a matter of fact, the old streetcar would stop up here at the golf clubhouse and the conductor would yell out "Tokyo golf and country club". So they would jump off with their clubs and play golf.

The two big water reservoirs in Jefferson Park were built in 1910 and were constructed on a portion of the large tract of park land. In 1935, after 25 years of reservoir operation, the Water Department gained full control of the 44 acres of the northwest segment of the park by officially purchasing the properties that house the reservoirs. The city water fund paid $50,000 to the City general fund in one of many convoluted swaps and purchases between the Parks Department and the Water Department that would take place over the years. There is conjecture that the purchase was made at this time, during the start of the depression years, because money was needed for the general fund.

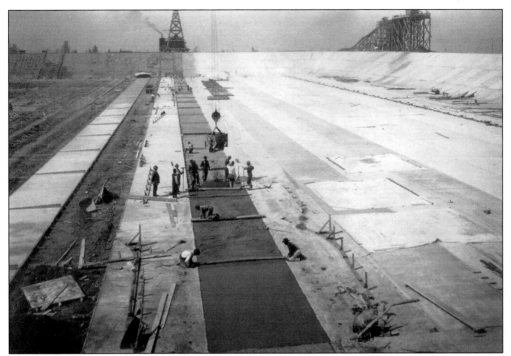

This photo from 1910 shows the construction of the north water reservoir at Jefferson Park. (MOHAI 3768.)

This view from 1910 shows the golf course on Beacon Avenue in Jefferson Park being built by prisoners from the city stockade. (Seattle Municipal Archives 31462.)

The prisoners stockade and farm beds in Jefferson Park are shown here in 1911. (Seattle Municipal Archives 31457.)

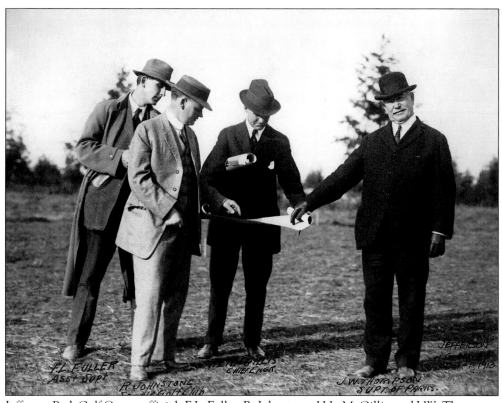

Jefferson Park Golf Course officials F.L. Fuller, R. Johnstone, H.L. McGillis, and J.W. Thompson are shown at green number eight in 1913. (Seattle Municipal Archives 29445.)

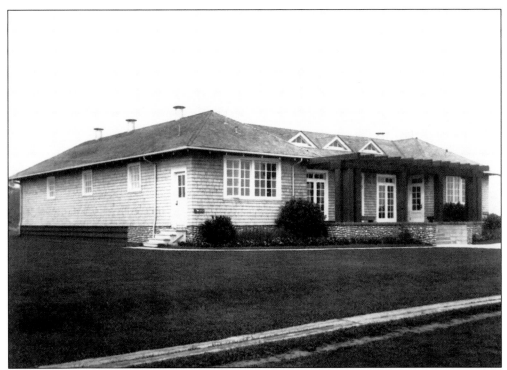

This photo by Asahel Curtis of the first Jefferson Park Golf Clubhouse, with stonework foundation, was taken in 1915. The clubhouse burned down in 1919. (MSCUA UW CUR 32098.)

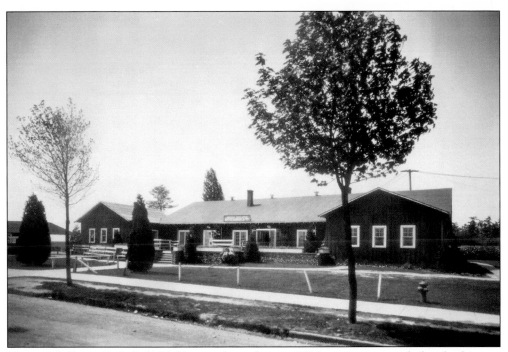

The new Jefferson Park Golf Clubhouse, shown here in 1920, was constructed after the first one burned down in 1919. (MOHAI 83.10.42.611.)

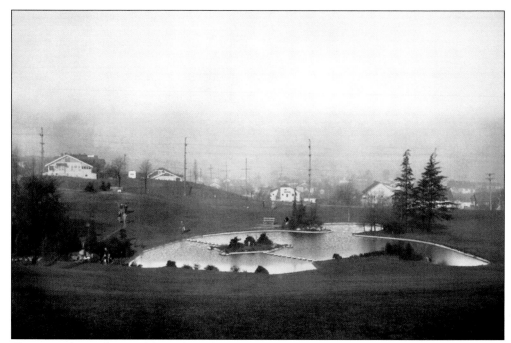

This view shows the pond hazard on the 18th hole of the Jefferson Park Golf Course in 1929 with Spokane Street and homes in the background. (MOHAI PI-24673.)

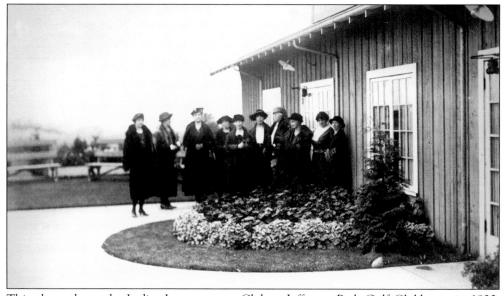

This photo shows the Ladies Improvement Club at Jefferson Park Golf Clubhouse in 1920. (Seattle Municipal Archives 29443.)

Golf Pro Joe Jefferson's former home in Jefferson Park, shown here in 1950, later became the first Jefferson Park Lawn Bowling Club House. (Seattle Municipal Archives 29460.)

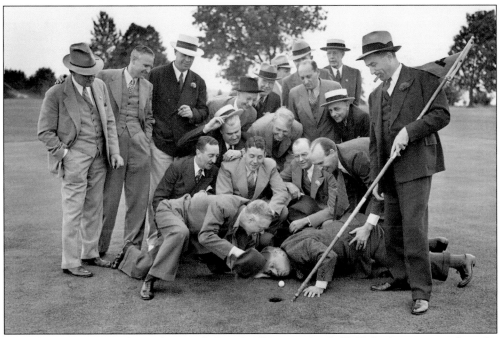

This photo from 1940 shows the *Seattle Post-Intelligencer* 101 Golf Club playing around on the 18-hole golf course at Jefferson Park. (MOHAI PI-26781.)

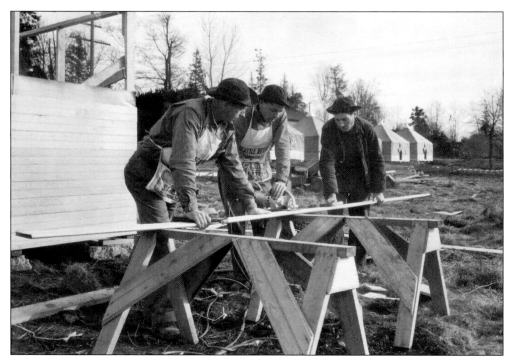

This photo shows the construction of the army recreation camp during WWII at Jefferson Park, c. 1943. (MOHAI PI-28215.)

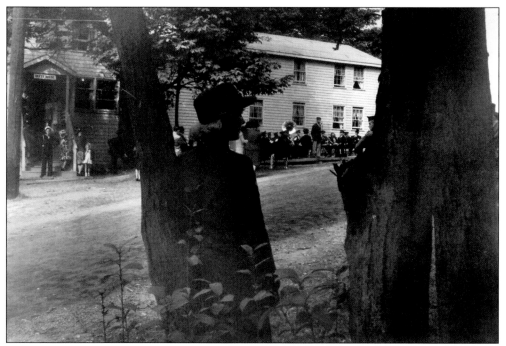

Seen here is a soldier in the trees outside the World War II Army canteen in Jefferson Park, c. 1943. (MOHAI PI-28218.)

This is a view inside the World War II Army Recreation Camp canteen c. 1943. (MOHAI PI-28216.)

A carnival was held at the Army Recreation Camp at Jefferson Park c. 1943. (Seattle Municipal Archives 29447.)

African-American golfer Bill Wright, at top right, arriving in Hawaii around 1960. Wright grew up playing at Jefferson Park Golf Course and, in 1959, was the first African-American to win the National Public Links Amateur Golf Championship. (MOHAI ALE 86.5.45081.)

Six

OFF TO SCHOOL

I started at Mt. Virgin Catholic School in the Rainier Valley and then my father got mad at the priest. You heard about Father Carmello there? He got mad at something he said, he called him "goat head" in Italian. My Father said, "That's it, you're out of that school, you're going to Colman School." At that time we didn't pay anything to go to Catholic school. He said, "I'm paying taxes. You can go to Colman."

—Joseph Forte

Children growing up on Beacon Hill at the turn of the century and in the early 1900s attended a scattering of fledgling public schools in the early years. These early schools included the original two-room 1899 Beacon Hill school at the north end of the hill, the larger 1904 Beacon Hill School built on the same site, the beautiful two-story 1900 Maple School near Georgetown, the 1909 Maple School on the site of Cleveland High School, and the 1909 Van Asselt School furthest south on the hill. Of these five structures, two are still standing. The 1904 Beacon Hill School is home to El Centro de la Raza, the Latino community service organization. The 1909 Van Asselt school building sits next to the new Van Asselt School.

Marge Haralson, born in 1933, went to old Beacon Hill School during World War II before going on to Cleveland High School. By this time the Japanese community had been taken away to the internment camps, the Chinese Exclusion Act had been lifted, and the Chinese community was growing and moving up to Beacon Hill.

I was at Beacon Hill from 1944–1948. I walked there from our house on Fifteenth and it was great. The general population at school in my class were predominantly Caucasians and Asians, mostly Chinese. I don't recall any Vietnamese or Koreans or Japanese. On the corner of Massachusetts and Fifteenth there had been a Japanese family that lived in that house. I was about eight years old. All of a sudden, I just had this vague recollection that they weren't there any more. It was very strange.

In later years, as the population grew, the Seattle School District expanded the number of schools in an effort to keep up with the child population, sometimes with the encouragement of organized residents who advocated for more schools. Looking at the histories of the individual schools, it appears that after World War II, there was seldom a time when portables were not in use at public schools on Beacon Hill. The school district had a hard time keeping up with the growth of families on the hill. The current demographics of the hill are reflected in the student bodies. According to Seattle Public Schools, children growing up on Beacon Hill today (as opposed to those enrolled who may be coming from other neighborhoods) speak 39 languages other than English as a first language.

For the high school years, there have been two primary choices for Beacon Hill residents: Cleveland High School, which is located on the south end of the hill at Lucille Street, and Franklin High School in the Rainier Valley at the central base of the eastern side of the hill. The

friendly rivalry among Beacon Hill kids who attended Cleveland and those who attended Franklin is long-standing. According to old-timers, the Beacon Hill Creamery, on Beacon Avenue, was a regular Friday night sparring ground for friendly insults and gags between rivaling student bodies from Franklin and Cleveland. In some cases, as the boundaries changed over the years, children in the same family attended different high schools, Cleveland or Franklin.

Bob Griffin attended Cleveland High School, graduating in 1943. Bob lived on the south end of Beacon Hill and transportation was always a consideration.

> *I went to Cleveland Junior High School, when it had junior and senior high school together. It was the only school in the city with both together. They had one bus in the morning, to take all of us on the south end of the hill down to Cleveland. At the end of the school day there was one to take us out this end again. And if you missed that bus, you walked out Fifteenth to Beacon and caught the regular bus when it came along and vice-versa. I turned out for sports, so when I was a freshman, I used to have to walk back and up and down the hill. Later on, when I was a junior, I bought a little 1937 Indian Scout motorcycle. So I was in hog heaven then. I would drive to school in the morning and go to band practice in the morning and football practice in the afternoon and I had my own little motorcycle.*
>
> *We had a number of Japanese at Cleveland High School, because they had the truck farms down in the valley. I don't remember too many Chinese, except for a couple of kids named Mar. There were also a lot of Italians. We had only two African Americans, one was a gal and her Dad was a policeman and a trainer for the Seattle Ramblers. His name was Claude Harris. And his daughter's name was Claudine Harris. They lived on the west side of Beacon, about a block down from the Aloha Market, which used to be the old Henderson Market. Then sometime during high school, as a sophomore maybe, they moved up into the Garfield District.*
>
> *I was never around a Black family other than that, never. I was much closer to the Japanese because I was born in Southpark. There was the Noritaki family right at the end of the block. They had about six kids. Then when we moved up to Beacon Hill, I didn't see them anymore. When I was in junior high school I ran into Sori Noritaki; she was in my class. Then they were displaced when they were sent away to the camps. They were really nice people. I think there were two boys and three girls. I was kind of close to Suwayo Noritaki because used to play together. I played football at Cleveland and I played one end and he played the other. We played together until they chased them out.*

After WWII, there were a number of new schools built on the hill. In 1950, the new Van Asselt Elementary School was built next to the still-existing 1909 school. In 1957, the school district constructed Asa Mercer Middle School near the golf course on the southwest side of Jefferson Park. The golf community opposed construction of the school in such close proximity to the course, but families advocating for a new school were well-organized in support of the project. The nine-hole golf course and driving range at Jefferson Park were relocated to make way for the school and nearby ball field. In 1971, four new elementary schools were built on Beacon Hill. Kimball Elementary school was constructed on 23rd Avenue South and the new Beacon Hill Elementary School was located on Beacon Avenue. Dearborn Park and the new Maple Elementary School were also completed in 1971. In the year 2000, the K-8 African-American Academy was built at the south end of Beacon Hill. This unique school features an African-centered education integrating the history, culture, and heritage of both African and African-American people.

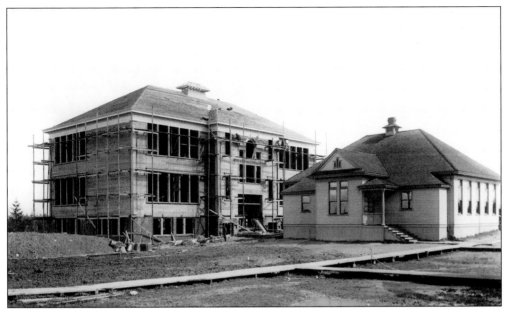

This 1904 photo by Asahel Curtis shows Beacon Hill School under construction with the original 1899 school in the foreground. (MSCUA UW CUR 04328.)

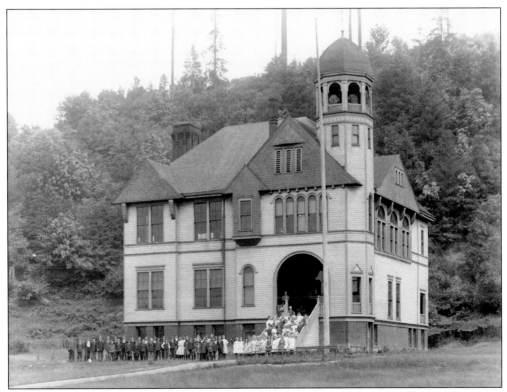

The first Maple School, a beautiful two-story structure with an elaborate bell tower, broadway stairway at the entrance, and window detail, was torn down soon after this photo was taken in 1907 to make way for the Oregon and Washington Railway. (MOHAI 83.10.7872.1.)

Students are shown here in front of the Cleveland High School greenhouse in 1930. (Seattle Public Schools 012-138.)

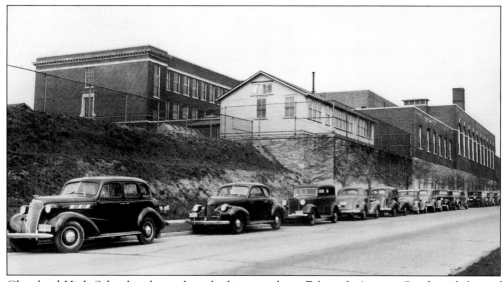

Cleveland High School is shown here looking north on Fifteenth Avenue South with line of cars, c. 1939. (Seattle Public Schools 012-6.)

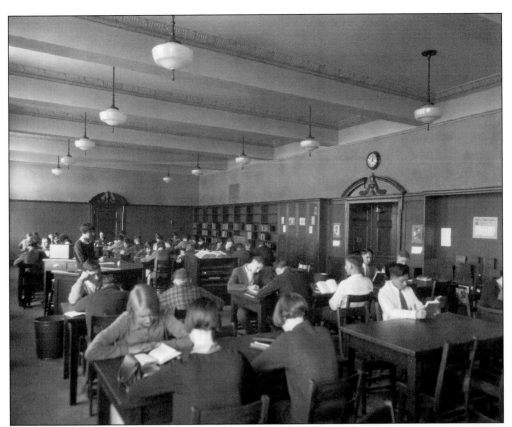

Cleveland High School library with students is pictured here in 1927. (Seattle Public Schools 012-1.)

This view is of a Cleveland High School science class, c. 1930. (Seattle Public Schools 012-137.)

This is a 1951 photo of a hamburger joint called Louie's Eagles Roost, which was a popular hangout for Cleveland High School students. (Marge Haralson.)

This picture from the 1951 Cleveland Yearbook shows a cheering crowd. (Marge Haralson.)

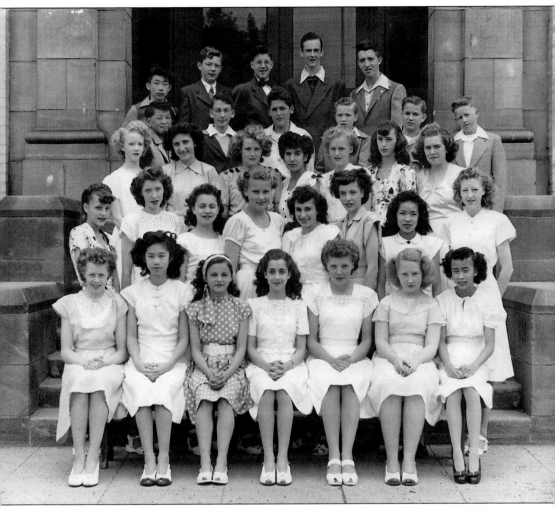

This picture shows the 1948 Beacon Hill School graduating class. Marge Foccana Haralson is fourth from the right, bottom row. (Marge Haralson.)

This is a 1937 photo of the Beacon Hill School Store on Sixteenth Avenue, across the street from Beacon Hill School. Next door is Mr. Ellis's Repair Shop, where kids could get their bicycle repaired. (PSRA.)

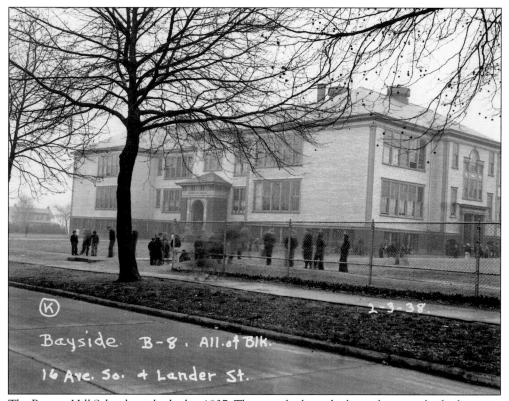

The Beacon Hill School as it looked in 1937. This view looks at the boys playground, which was on the south west side—the girls' playground was on the south east side of the building. (PSRA.)

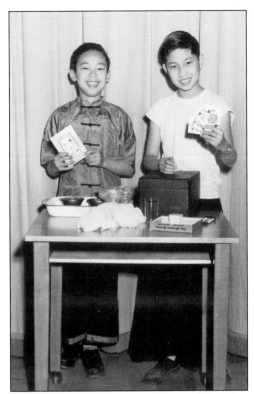

At Asa Mercer Middle School, a drama student poses with a guitar, *c.* 1960. (Seattle Public Schools 110-14.)

Two boys put on a magic show on stage at Asa Mercer Middle School, *c.* 1960. (Seattle Public Schools 110-9.)

The Asa Mercer Skyliners jazz band poses for this photo in the 1960s. (Seattle Public Schools 110-115.)

Asa Mercer Middle School occupational education class shows their motor scooter project in 1972. (Seattle Public Schools 110-81.)

Shown here is the 1971 Cleveland High School "Consumer Education" class with teacher Helen Cavanaugh. (Seattle Public Schools 012-136.)

1960s Asa Mercer Middle School drama class with sailors in pyramid (Seattle Public Schools 110-8.)

A female drama student in the 1960s at Asa Mercer Middle School stands on her hands. (Seattle Public Schools 110-11.)

1960s Asa Mercer Middle School drill team in sailor suits in V formation (Seattle Public Schools 110-7.)

In 1970 ground was broken for the Kimball Elementary School. Mrs. Kimball is shown here attending the ceremony. (Seattle Public Schools 288-10.)

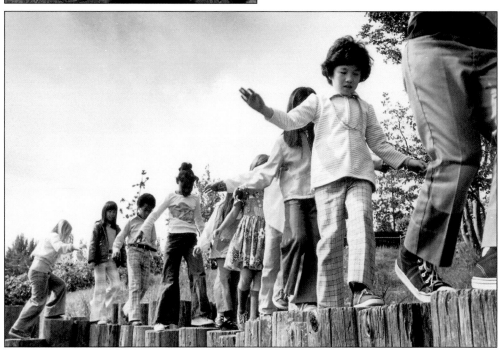

In this 1976 photo, children at Kimball Elementary walk on playground posts. (Seattle Public Schools 288-10.)

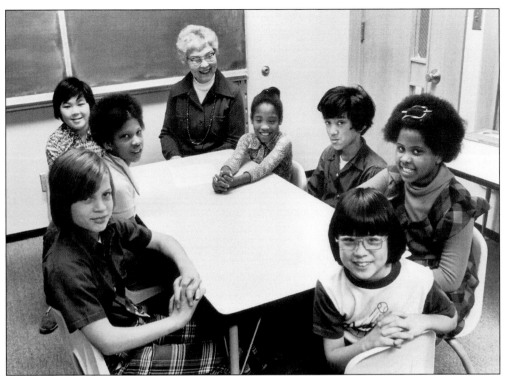

In 1970, at the new Beacon Hill Elementary School, social worker Helen Nieberl sits in on a meeting of the Beacon Hill Student Council. (Seattle Public Schools 205-41.)

Shown here is the groundbreaking ceremony in 1970 for the new Maple Elementary school; present are relatives of Joseph Mapel for whom the school was named. (Seattle Public Schools 252-9.)

The African American Academy is shown here under construction in 1999, with a worker in the foreground. (Seattle Public Schools 503-043.)

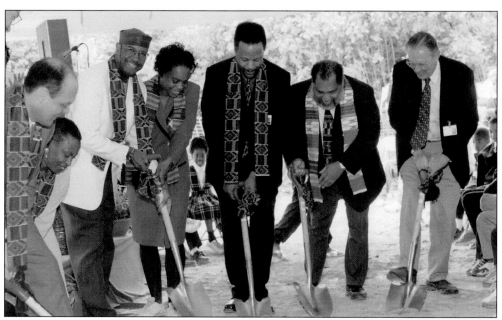

Pictured here is the 1999 African American Academy groundbreaking ceremony with Superintendent Joseph Olchefske, Vivian Phillips, Tony Orange, PTA President Betty Jean Sanders-Stanton, school board member Michael Preston, Dr. Collin Williams, and John Vacciery. (Seattle Public Schools 503-03.)

Seven

ENTERTAINMENT

It was 1955 and that was the first time I had ever been to Beacon Hill, my very first day in Seattle. And I even remember the starting pitcher for the Seattle Rainiers, he was a lefty, and his name was Donoso. I thought "Oh my God! A Mexican pitching," and I started asking around and it turned out he was a Filipino. Which was close enough.
—Roberto Maestas

Don Duncan was born in 1926 and remembers as a youth thinking that Beacon Hill was the center of the world. It isn't surprising, given some of the significant Seattle institutions that were located in the south end. The baseball stadium was on Rainier Avenue at the eastern base of Beacon Hill, the Boeing Airplane Company was on the western side of the hill, the industrial district which employed so many families from the hill was also just west of the hill, and Chinatown and downtown Seattle were a short bus ride away to the north. The Beacon Avenue theater provided movies and the beaches of Lake Washington were a short bike ride away.

Sports activities provided important opportunities for community gatherings and entertainment for families who were otherwise occupied with the struggles of daily living. For immigrant children, participating in sports built self-esteem, created community ties, and could foster greater acceptance with other children in the neighborhood or school. From 1920 until 1941, young Japanese families with children gathered at picnics hosted annually by the Japanese language school. For many years these picnics were held in Jefferson Park. Baseball was one of the primary activities of the picnics, along with field races and exercise/dance performances. Many young men growing up on the hill in the '30s and '40s worked as caddys at the Jefferson Park golf courses, receiving an education in etiquette and work ethic. During the years when active sports like basketball and baseball were unavailable to girls, bowling providing a socially acceptable activity that mixed younger and older members of the community as well as boys and girls in one setting. The Imperial Lanes on 22nd Avenue South has been a gathering spot for Beacon Hill teens and residents since 1958.

As new sports opportunities opened up to girls in the seventies, physical education advocates like former P.E. teacher Cheryl Chow and tennis star Amy Yee volunteered their time to educate and coach girls and boys in sports. Cheryl Chow organized the first Chinese girls' basketball teams in cooperation with the Seattle Chinese Athletic Association and also supervised the Chinese Girls Drill Team, a tradition started by her mother Ruby Chow. Amy Yee grew up on Vashon Island but spent much of her adult life coaching, organizing, and playing tennis on Beacon Hill. Amy Yee was born in 1922 and excelled at tennis, winning numerous state and national tournaments. She founded tennis camps for kids which are still run by her daughter and son, Joyce and Gordon Yee. Dr. Roy Mar, local dentist and uncle of Cheryl Chow, has also been a long-time volunteer, coaching sports with children on the hill.

Beacon Hill residents have a long history of following professional baseball. Sick's Stadium, home of the Seattle Rainiers, opened in 1938 on McClellan and Rainier Avenue South. The

voice of radio announcer Leo Lassen calling the games drifted through front door screens and down the street. John Scheier was born in 1928 and grew up on the hill. He went to the games and worked across the street when he was older.

> *We would listen the games on KRSE while mixing a bowl of wheaties. Leo Lassen was the broadcaster. Across the street from Sick's Stadium was Andy Martin's Mobile Station. I used to service the ball player's cars there. I remember in 1946 when "Cupie" Dick Barrett won two ball games in succession, a nine-inning game and a seven-inning game, and won a $500 bonus. It was a special night and they gave him a brand new gray Henry J. Kaiser car. I had to wash and lube that car and it was spiffy looking.*

Before Sick's Stadium, Dugdale Park occupied the same site. Dugdale Park burned down in 1932. Pete Caso was born in 1923 and lived near Twenty-second and Hanford Street on Beacon Hill.

> *It was a big fire. We saw the ambers going up from our house. I watched games down there at the old stadium. We used to go down around the second or fifth inning. There was a big farm along my house and there was nothing in there but woods. We used to call it Riley's Woods. We used to walk through the middle of Riley's Woods, corner to corner, to get to the stadium.*

At the intersection of Columbian Way and 15th Avenue South the Serbian Hall hosted local community dances, wedding receptions, and other parties. Roberto Maestas came to Beacon Hill as a teenager in 1955 when there were few other Latinos living in the area. Consequently, he developed a close relationship to the Italian community. He remembers attending Italian community dances at the Serbian Hall.

> *As a kid in Georgetown, I got connected with a bunch of Italians. There were really high concentrations of Italians in South Park and in Georgetown. So we got along famously and did what people did at 17, 18, 19, 20 years of age and we would go to a monthly dance of the Italian club, the Sons of Italy. Us Chicanos would get extremely excited about it because there were some amazingly beautiful Italian girls that would go and everybody got decked out in those days and it was thrilling, out and out thrilling. And then we met some Germans somehow, and we thought, "Could it be kind of the same?" And we said, "So, do you Germans get together?" And they said, "Yeah, well we have dances." And they had dances in the Capital Hill area. So we went to those dances and it was the same phenomena. Some of the most beautiful women on the planet Earth are German and we hung out with the Germans and everybody was very friendly."*

Beacon Hill residents also have fond memories of the Beacon Hill library, which was originally located just north of the South China Café. This small storefront library featured a pot-bellied stove in the back. In later years, the library moved down to the junction of Beacon Avenue and Fifteenth Avenue South. Local resident and first generation Hong Kong immigrant Rebecca Lunn arrived in the United States in 1962 at the age of ten. She remembers spending many happy afternoons at the Beacon Hill library with her siblings. She says it was their second home. They checked out as many books as they could carry and played library at home. Don Duncan, former writer for the *Seattle Times*, was an active patron of the Beacon Hill library in the '30s. After setting a record for reading 68 books in one year, he was given permission to check out adult books at the central library downtown. The central library staff directed his reading and the first book they recommended to him was Mary Roberts Rinehart's *The Circular Staircase.*

Beacon Hill school kids pick sides for a baseball game in 1961. (*Seattle Times.*)

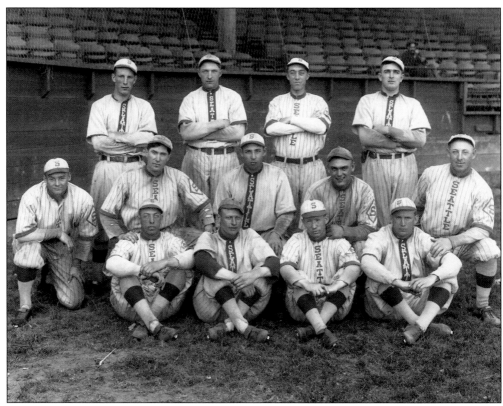

Shown here in 1915 are the Seattle Giants at Dugdale Park at McClellan and Rainier, at the eastern base of Beacon Hill. (MOHAI 83.10.10.156.)

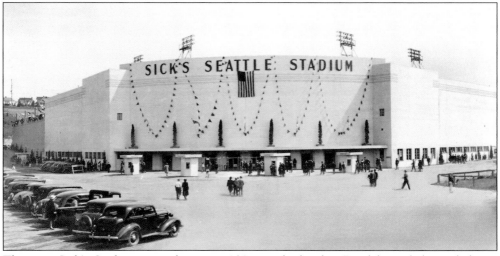

The new Sick's Stadium, seen here in 1938, was built after Dugdale Park burned down. (MOHAI 83.10.4858.)

In the 1930s radio announcer Leo Lassen was the voice of the Seattle Rainiers Baseball Club. (MOHAI SHS 17,300.)

Pat and Nick Vaca's vegetable farm east of Sick's Stadium was a good spot to see the ballgame for free, as seen here in 1940. (MOHAI PI-27043.)

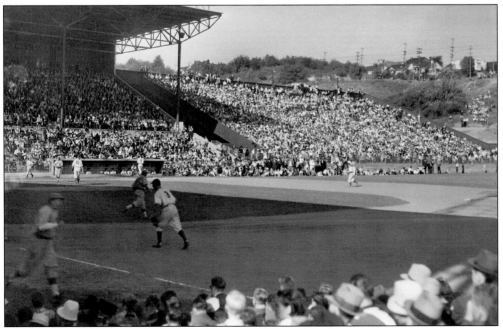

This photo shows a Seattle Rainiers Baseball game at Sick's Stadium in 1940. (MSCUA UW 15727.)

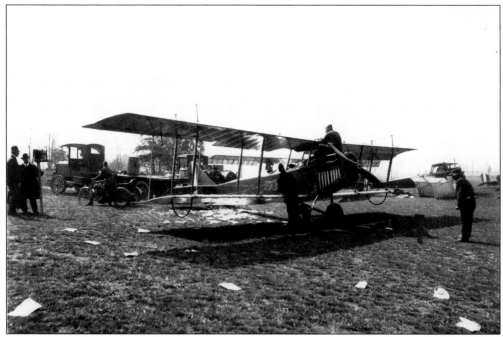

This 1919 photo by Asahel Curtis shows biplanes and aviators at an air show on the Jefferson Park golf course. (MSUCA UW CUR 37942.)

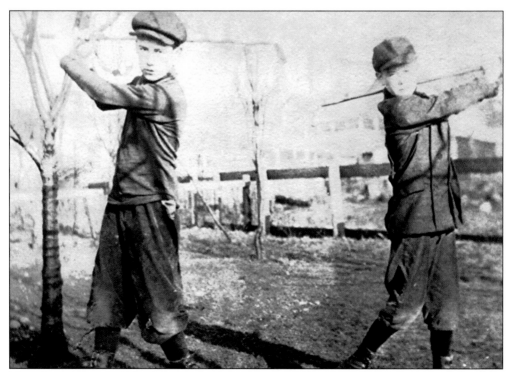

This photo, taken in 1919, shows a popular activity with Beacon Hill boys: two DeVos brothers working up at the Jefferson Park golf course as caddies. (DeVos family.)

The first Beacon Hill branch of Seattle Public Library was on Beacon Avenue near Lander Street. It is shown here in 1945 with a pot-bellied stove in the storefront. (MOHAI 1986.5.11212.1.)

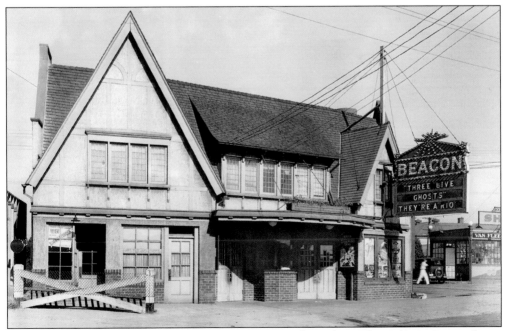

The Beacon Hill Theatre, as seen here in 1935, showed serials and movies, and was located in the "junction" at Beacon and Fifteenth Avenue, across from the ice cream shop. (MSCUA UW 14659.)

Mrs. Wickman's Pie factory, shown here in 1937 next to the Wickman home with delivery trucks. (PSRA.)

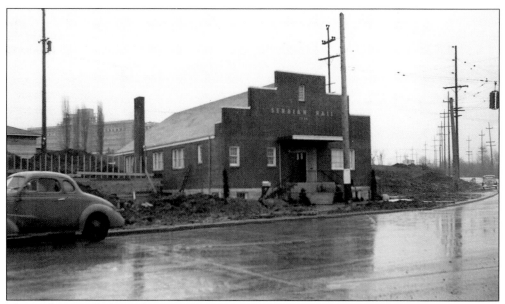

The Serbian Hall, located at Columbian Way and Fifteenth Avenue south, hosted Italian community dances and other celebrations, as seen here in 1937. (PSRA.)

Eight

HOME AND FAMILY

My father's ethnicity is German and my mother is half Austrian and half French. Dad came to Seattle for work. He painted houses all his life. He also used to teach stenciling and he did stenciling on some churches. He did the stenciling at St. Mary's in the Roosevelt neighborhood. First he put the stencils on canvas and then he pasted it up.
　　　　　　　　　　　　　　　　　　　　　　　　　　　—John Schreier

During World War I there was a shortage of housing that spurred construction. At that time, Seattle was a center for shipbuilding. In 1918 Skinner and Eddy ship builders constructed the Liberty Court project with 136 units at Fourteenth and South Lander for shipyard workers. The Liberty Court was later remodeled to become Lago Vista Apartments.

The 1920s was a boom period for Seattle and a lot of apartment buildings were built at this time. The Jefferson Park Apartments sit across from the main entry to the park on Spokane Street and Beacon Avenue. They were constructed in 1925.

In the Lockmore area, a sub-neighborhood of Beacon Hill, the Morey family built their home at 4866 Twenty-eighth Avenue. The neighborhood is named for this lovely brick Tudor house, which the family named Lockmore. The name came from a combination of Mrs. Morey's maiden name, Lockwood and the name Morey. The Moreys built this house as their family home and built several houses around it in the neighborhood on orchard land they had purchased from an Italian farmer. A few years after Mr. Morey died the family leased the house to Yokohama Specie Bank (a Japanese national bank), and it was used as the residence of their Seattle-based general manager. When World War II broke out and all the Japanese were moved to internment camps, Mrs. Morey and her daughter moved back into the house. They took in boarders in order to qualify for enough heating oil to heat the house, which was being rationed by numbers of residents. Most of the boarders were single men, most of whom worked for United Airlines.

Even in the early 1930s, just before the Depression, a few apartments and commercial buildings were constructed on Beacon Hill. The Lora Apartments, on Sixteenth Avenue near the new Beacon Hill library, were completed in 1930. A two-story brick building at 3320 Beacon Avenue South was built in 1930 with a drug store on the first floor and living quarters on the second floor. In the 1940s it housed a grocery store run by the Falsetto family. A Japanese family later ran the grocery until the early 1970s. It served as an art studio for about ten years, and it now houses the Day Moon Press Printers.

During the Depression, shanty housing, essentially shacks, became a problem on the western hill climb of Beacon Hill. A shantytown called "Hooverville" was located nearby in the industrial lands south of downtown. In 1938 the city passed a resolution addressing the problem of shacks on Beacon Hill. Don Duncan and his mother Roberta lived on Beacon Hill for many years and he talks about the housing situation in the '30s.

When I was eight, mom found a place on 1509 Winthrop Street. The only way you could survive was to share. We rented from Mrs. Detters. Mrs. Detters lived in the basement and rented out

the four places she could call apartments. We shared the bathroom with the lady upstairs. We had two rooms, a little kitchen and mom's iron bed on one side and mine on the other. This is where we spent most of our years. It was $12 dollars a month and when they raised it to $16, we didn't know if we would ever be able to pay it, because that was an awful lot of money.

After World War II, I went back to live with my mother on Beacon Hill. We moved out of 1509 Winthrop Street. Mom said to the landlady, "We really hate to leave, but my boy really doesn't like to sleep in the same room with his mother now that he is in college."

During World War II there was a severe shortage of housing. People were coming to Seattle with the military and to work for Boeing Airplane Company, located just west of Beacon Hill. Many of the homes constructed south of Spokane Street and Jefferson Park went up in the 1940s to meet the needs of the wartime housing boom and the needs of shipyard and Boeing workers. The Army recreation camp built in 1942 in Jefferson Park provided beds for Army personnel who had no other shelter and were walking the streets at night because all the hotels were full.

Ron Chew, director of the Wing Luke Museum, has learned that housing discrimination on Beacon Hill existed into the '60's.

There were still restrictive covenants on Beacon Hill at that time because I have talked to people who were seeking apartment housing or to purchase housing on Beacon Hill and they still had difficulty in the '60's. I think it was really was with the passage of the Open Housing Act and the Civil Rights Movement that things began to open up. City Council member Wing Luke was involved in the passage of the City portion of those laws.

Low-income housing was built by the Seattle Housing Authority at Holly Park in central-south Beacon Hill and Rainier Vista on the eastern flank of Beacon Hill below Jefferson Park. Rainier Vista, with 481 units of housing, was constructed in 1941–1942. Holly Park had 900 units and was completed in 1943. These large developments provided affordable housing to hundreds of families coming to this area for work and served as a welcome mat for new residents of Beacon Hill.

Clifford Holland is one African American who grew up in Holly Park and later bought a home on Beacon Hill.

I was born in April 1948 when we were over there at Holly Park. My Mother, Luella Holland, hooked up with my father during the war. He was a sailor over in Bremerton. They got married and the housing was over here in Holly Park. That's how we ended up there. Holly Park was built as temporary housing to house all these people for the service, and shipyard and Boeing. I think that the housing shortage started a little bit before the war. My mother came in 1944 and it had been happening for a while. Ethnically, it was a high percentage of Blacks but there were a lot of Whites too. Not that many Asians, but an awful lot of Blacks. It seemed like everyone that was coming here grew up in one of the housing projects.

One of the most spectacular homes built on Beacon Hill belonged to Frank and Kate Black, owners of Black Bear Manufacturing. The Black residence was built in 1889 at 1319 Twelfth Avenue South. Black Bear Manufacturing was a prominent employer for local residents. Japanese and Chinese women worked as garment workers for Black Bear Manufacturing. Italian-American Joe Forte grew up on Sturgis Avenue, down the hill from the Blacks and his brother Christopher worked for Black Bear as a salesman. The Black residence included an orchard, picnic grounds, gardens, arbors, fish ponds, a river rock cabin, and fantastic views from the northwest edge of the hill. According to Pete Caso, Katie Black also owned one of the only horses on north Beacon Hill and was driven to the public market for shopping in a horse drawn carriage in the thirties. Katie Black's garden and two ponds have been preserved, but the house and much of the grounds of the residence have been replaced with apartment buildings.

The Foccona family home in 1925, near Massachusetts Street, with father Giuseppe's garden where he grew sauce tomatoes for canning, and garlic which he sometimes sold. (Marge Haralson.)

Teresa and Rose Foccona are shown here in wicker chair in 1927. (Marge Haralson.)

This photo from the 1930s shows the delivery of DeSanto and Scaringi zinfandel grapes for wine-making to the Italian community. Marge Haralson's father, Giuseppe Foccona, made wine for the family table each year. (Festa Italiana P5150276.)

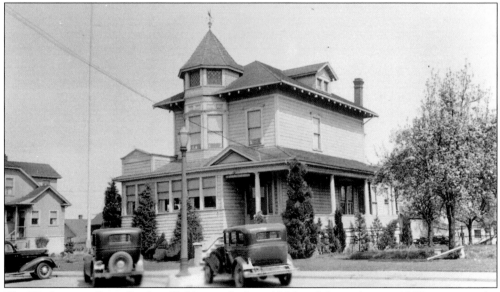

The Washington State Garden Clubhouse, built in 1886 and shown here in 1937, was once the Jefferson Park Ladies Improvement Clubhouse, and before that Judge Turner's home. It is the oldest home on the hill still standing. (PSRA.)

Joe Bellotti's parents' wedding picture is shown here. They are standing in front of their first home on Atlantic Street in "garlic gulch." Later they built the home pictured below. (Festa Italiana P8040040.)

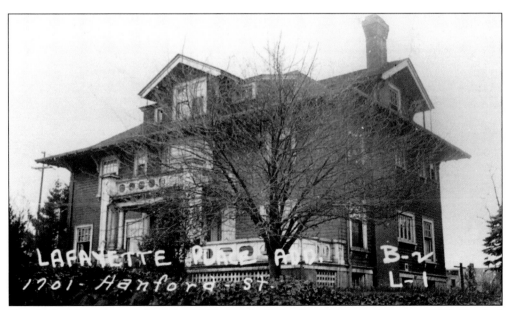

The Belloti home, seen here in 1937, was built by Joe Bellotti's father at 1701 Hanford Street South. (PSRA.)

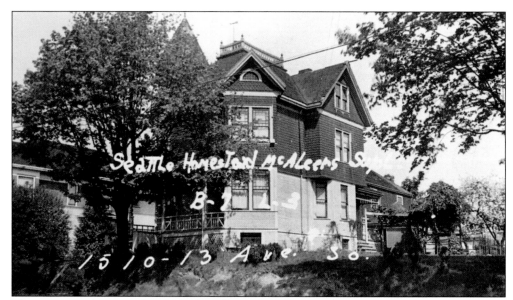

This two-story home with a widow's walk at 1510 Thirteenth Avenue South, shown here in 1937, was built in 1893. (PSRA.)

This photo, taken in 1937, shows the cedar siding and stucco home at 1723 Thirteenth Avenue South. It was built in 1904 and purchased by Raymond Jung in 1964 for $32,000. It was torn down to build the Beacon View Apartments in 1968. (PSRA.)

This two-story apartment building with three units, built in 1906 at 1531 Thirteenth Avenue South, seen here in 1937, was later remodeled to become a nursing home. (PSRA.)

This two-story home built in 1898 at 2512 Fourteenth Avenue South, and shown here in 1937, was later demolished. In 1968 apartments were constructed on this site. (PSRA.)

This Lockmore home was built in 1927 at 4866 Twenty-eighth Avenue South by the Morey family. Shown here in 1937 it was 2,246 square-feet, and had 16 plumbing fixtures, extensive interior tile work, and ornamental copper downspouts. (PSRA.)

This 1937 view shows a brick home built in 1929 at 4336 Fourteenth Avenue South in the Lockmore neighborhood. (PSRA.)

This photo, taken in 1937 shows the Frank Black house at 1319 Twelfth Avenue South. It was built in 1889 with 2,144 square-feet of floor area and 14 plumbing fixtures. (PSRA.)

This 1937 view shows the river rock cabin on the Frank Black property built in 1889. The property included an orchard, picnic grounds, and fish ponds. (PSRA.)

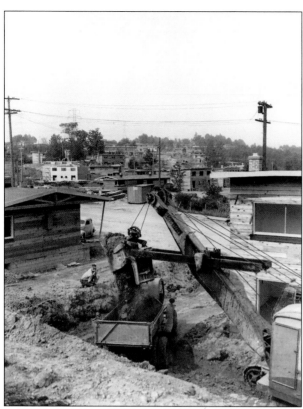

This photo by Mark Kauffman, taken in 1942, shows the construction of the Holly Park low-income housing project. (MSCUA UW 23035z.)

This 1942 photo by Mark Kauffman shows the newly-constructed Rainier Vista housing project with water tanks. (MSCUA UW 23036z.)

Skinner and Eddy, ship builders, constructed Liberty Court apartments in 1918 for shipyard workers. This photo was taken in 1937. (PSRA.)

The Liberty Court Apartments, seen here in 1961, was remodeled with stucco and brick veneer to become the Lago Vista Apartments. (PSRA.)

This four-room, 552 square-foot home on 1312 Tenth Avenue South, shown here in 1937, was built in 1913 and sat on an ungraded street on the steep western slope of Beacon Hill. (PSRA.)

Nine

CHURCHES, ORPHANAGE, HOSPITAL, AND CEMETERY

We went to St. Peter's Catholic Church. The church started out at the Beacon movie theatre. We had mass in that building while it still operated as a movie theatre.
—Dan Lagozzino

The earliest churches on the hill were St. George Catholic Church, originally established on the western edge of the hill in Georgetown, and the Beacon Hill Congregational Church at the north end of the hill. St. George drew parishioners from the Italian and Belgian community as well as Irish, French, Austrians, Poles, and Spaniards. Catholic families on the north end of the hill went to Mt. Virgin Catholic Church across Rainier Avenue. Beacon Hill Congregational was the center of church social life for the Protestant community. It seems that both the Catholic and Protestant churches had a sociable character derived from serving a very mixed group of European ethnicities.

The Sacred Heart Orphanage was established by Italian missionary Mother Francis Cabrinni in the early 1900s. It was located just across the Twelfth Street Bridge, north east of Frank Black's house, before the construction of the Marine Hospital. Mother Cabrinni traveled throughout America from 1889 until 1917, founding schools, hospitals, and orphanages. Most of her work was done in New York, Chicago, Seattle, and New Orleans. She died an American citizen in Chicago in 1917, having taken her oath of citizenship in Seattle, in 1909. According to Joe Forte, who lived on Sturgis Avenue just east of the orphanage, Mother Cabrinni was a good sales lady. She went door to door asking for donations to maintain the orphanage.

> *You know where Pacific Medical is? That is where Mother Cabrinni had her first orphanage. It was a big house. My mother remembers her going around begging, especially at the Italians. She begged for help at the orphanage, mainly for little kids. Mother said she was a good beggar. She could get anything out of you.*

The north face of the hill was lowered to meet the steel bridge deck of the Twelfth Street Bridge in 1923. Given the location of the orphanage, directly in front of the bridge, it is likely that the orphanage was closed or moved when the face of the hill was altered. About ten years later, the Marine Hospital was constructed on a large site that would have included the original site of the orphanage. The Marine Hospital opened in 1933.

Don Duncan remembers the Beacon Hill Congregational Church on Sixteenth and Forest as the center of religious activities up on Beacon Hill in the thirties. Don talks about one early positive experience at the Beacon Hill Congregational Church.

> *I had my first success there in artistic matters. I'm left-handed and very inartistic. The nice Sunday school teacher (who got killed in World War II) said, "All right boys, we are going to have a soap carving contest." I didn't have any soap but somebody gave me some soap and I did it but I didn't*

let anybody see it. My cousin, who later became an architect, he was a great artist and he did a Noah's Ark with all this neat stuff and somebody else did an automobile with fenders. I wasn't going to let anybody see mine so I wrapped it up in a handkerchief and kept it hidden. So it comes the time and the teacher said he had two ribbons to give, a red and a blue. The blue one went to my cousin. Mine was unveiled as I put it out there along with the rest, and the boys sniggered, "Duncan carved a 'necked' lady!" The Sunday school teacher looked at it and he knew I was the object of derision at that point. He said, "I'm going to give second prize to this beautiful sculpture of Eve as she must have looked in the Garden of Eden." Of course, I hadn't even thought of it quite that way. Finally, he said, "How did you happen to carve that Donald?" I said, "I was looking through the encyclopedia at school and I saw a picture of this pretty lady, but she didn't have any arms. So I gave her some arms." It was the Venus de Milo that I had copied. I gave her arms and big clumsy feet and I got the prize. The boys were quite taken with this.

After World War II, the church communities on the hill became more diverse, with the Asian-American influence rapidly increasing in prominence. Today the Catholic churches at St. George and the newer St. Peter's Church both have large Filipino membership as well as many Samoan and Latino families. Buddhist temples serving the southeast Asian community have been built on southeast Beacon Hill. The Ethiopian community has one of several storefront churches on the hill. There is a Greek Orthodox Church located on Thirteenth Avenue South that was built in 1960. The African-American congregation at the Beacon Hill First Baptist Church holds services in the historic building that formerly housed the Congregational Church.

In 1977 the Chinese Baptist Church built a large new church on Beacon Hill, moving up the hill from their founding location in Chinatown. This change was an acknowledgement of the changed status of Chinese families. Needing family-sized housing as immigration rules were loosened during World War II, the Chinese community had begun moving out of Chinatown, up Jackson, and across the Twelfth Street Bridge to nearby Beacon Hill in 1943.

State Representative Sharon Tomiko-Santos came to Beacon Hill from San Francisco in 1971 when her father accepted a post at the Blaine Methodist Church on Twenty-fourth Avenue South. She was ten years old when the family moved to the parsonage house at 3038 Nineteenth Avenue South. Mr. Tomiko was hired as the Japanese language minister to work with the older Japanese congregation, many of whom spoke primarily Japanese. Blaine Methodist and many other churches on the hill have been important social centers for the various ethnic communities on the hill, providing a source of social identity and opportunities for community gathering, celebrations, and youth education.

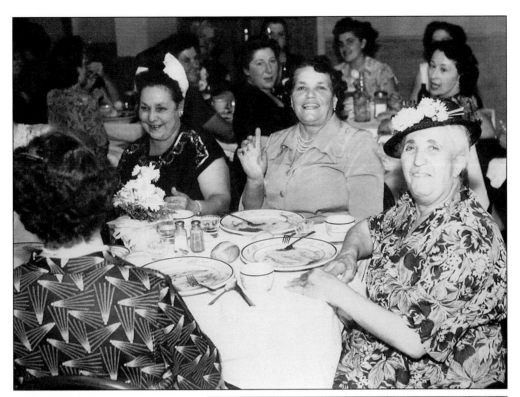

This image shows a 1940s luncheon at St. Peter's Church with the ladies. (Festa Italiana P9080208.)

In the 1940s Rose Ferraro and her twin sister Mary pose for a twin photo contest. Rose Ferraro cooked frequently for events at St. Peter's Church. (Rose Ferraro.)

This photo shows the christening of Louise Forte, born to Michael and Rosina Forte, at the turn of the century. (Festa Italiana P9080214.)

Marge Haralson's older sister Teresa Foccona, born in 1921, and Godmother Susie Russo are shown here at Teresa's confirmation. (Marge Haralson.)

Theresa Valalla, Marge Foccona (Haralson), and Virginia Forte, are seen here at a solidity party in the basement of the Belloti home on Hanford Street. Virginia Forte later took her vows as a nun. (Marge Haralson.)

Pictured here are children at Mt. Virgin Catholic school. Located east of Beacon Hill, across Rainier Avenue, many Italian families from Beacon Hill sent their children to school at Mt. Virgin. (Festa Italiana P9080351.)

St. George Church
and Parishioners

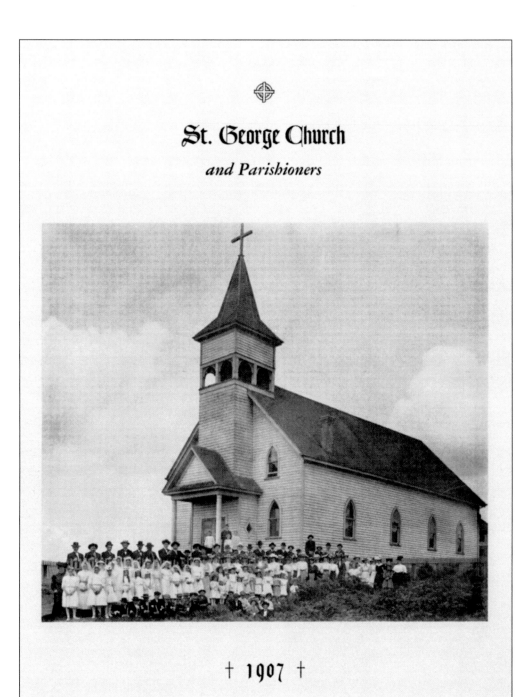

† 1907 †

Shown here in 1907 is the St. George Church and parishioners. The church was relocated to make room for Interstate 5. (St. George Parish.)

This 1904 view shows the sanctuary from the original St. George Church. (St. George Parish.)

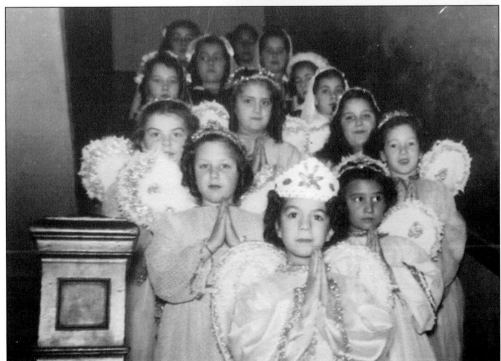

This close-up shows angels at the Mt. Virgin Church. (Festa Italiana P9080376.)

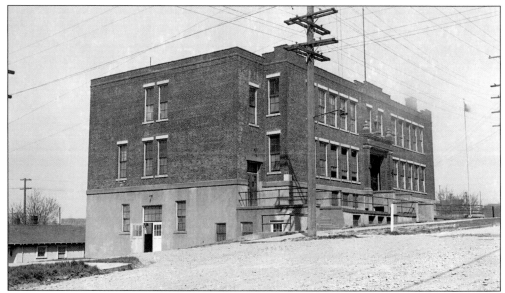

The St. George School, built in 1919 with 20 rooms at Thirteenth Avenue South and South Dawson Street, is shown here in 1937. (PSRA.)

The new St. George Church is shown here in 1954. (St. George Parish.)

The Beacon Hill Congregational Church, built in 1911, as it was in 1937. It was later purchased by the Beacon Hill First Baptist Church in 1970. (PSRA.)

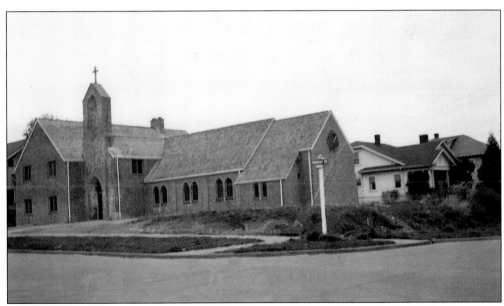

Beacon Hill Lutheran Church was built in 1950 at 1722 Forest Street South. (PSRA.)

The St. Peter's Rectory was built in 1931. This photo was taken in 1937. (PSRA.)

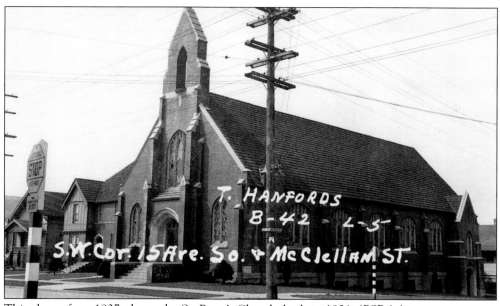

This photo, from 1937, shows the St. Peter's Church, built in 1931. (PSRA.)

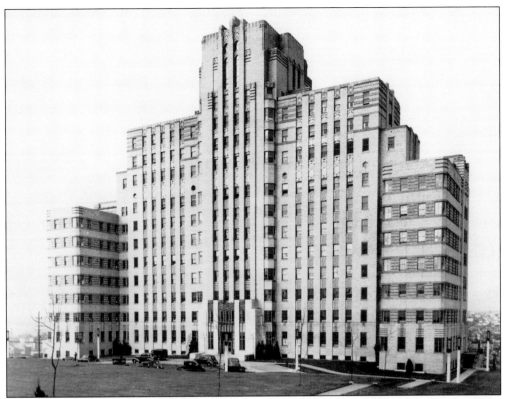

The Marine Hospital, at the north end of Beacon Hill, as it was in 1933. (MOHAI SHS 11532.)

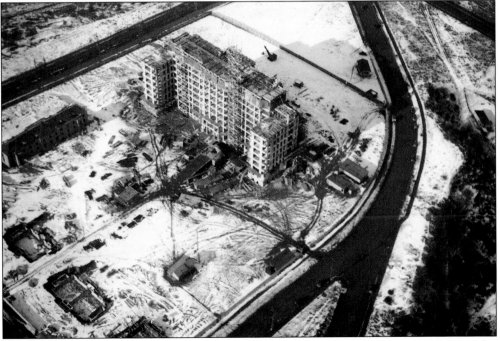

This 1932 aerial view shows the Marine Hospital under construction. (MOHAI 1986.5.9424.1.)

AT THE GRAVE OF JOHNNIE JONES — OLDEST BREWERY WORKMAN OF GEORGETOWN WASH. MAR. 20 - 1910

This photo shows the burial of Johnny Jones (DeVos family) the last brewery worker, at the Comet Lodge Cemetery on Graham Street in 1910. The first burial at this cemetery was in 1880, and the last burial was in 1936. It was owned by the Independent Order of Odd Fellows until 1912, when it was sold to Mr. Noice. Homes have been built on part of the cemetery.

Ten

EL CENTRO DE LA RAZA

Roberto Maestas was my Spanish teacher in high school, a typical straight teacher who all of a sudden found his calling and rediscovered himself in this period of activism as a Chicano. He was this guy with a headband who removed his suits and cologne and became a different person. I remember it quite well, this transformation.

—Ron Chew

The original two-room Beacon Hill School, built in 1899, was the first school on the hill. It was located on the same site as the much more substantial, two-story Beacon Hill School built in 1904 (now home to El Centro de la Raza). The original two-room building remained on the site until 1988 when it burned down. The design of the beautiful 1904 Colonial Revival style school was based on a model school plan also used in other parts of the city.

In 1971 the new Beacon Hill Elementary School was constructed and the old building was left vacant. In 1972 a group of local activists with the War on Poverty occupied the building. Among these activists was Roberto Maestas, now director of the Latino community service organization, El Centro de la Raza. He was interviewed by the students of the Seattle Academy of Arts and Sciences for a book entitled *Seattle Works for Rights*, published in 2003. The following is an excerpt from the chapter on Roberto Maestas, written by Jennifer Hoyt, Sophie Laster-Hazzard, J.P. Snyder, and Emma Strong.

After I left the University of Washington, I began to work in the community in the south end with poor people—very, very, poor people. Back in the '70s there was a project called the War on Poverty. President Nixon decided there was not enough money to fight the war in Vietnam and the War on Poverty. He had to choose and he made a terrible choice. He chose the war in Vietnam and abandoned the War on Poverty. When the government tried to shut down the War on Poverty, we decided to take over an abandoned school building so that we could still help poor families. That building used to be called Beacon Hill School. The Seattle School district didn't need it any more. It was sitting there boarded up. It was ugly, a horrible eye-sore. When I had been a kid of 14 or 15, I used to play basketball at that school. Beacon Hill School was in my new neighborhood.

I said to the poor people we were working with, "The Nixon administration has abandoned the War on Poverty, which means that all of you that are studying, all of you who are teaching, all of you who are helping find jobs for people, we ain't got a job no more. So we can all go our own way. You go here and you go there, you go elsewhere and good luck. Or we can stick together and be a family. We can go over to that school building that's abandoned, we can walk in there, and use it. We can live in there and fight for it, and maybe some day we can leave it a beautiful place for everybody, especially our children."

So we went, even though we didn't have permission. Was I afraid? No, I don't think I was afraid. I grew up in a little village in New Mexico. When you grow up in the hills, in the woods, in the mountains, I think you learn to be confident. There are rattlesnakes, cliffs, floods in the river,

119

cattle, horses, goats. I think I lost fear early on. If you can conquer fear—fear that somebody will laugh at you, fear that you may lose your job, fear that you may fail at something—there is nothing that you cannot do. If you fail, you just get up and try again, or try something different. You keep trying, trying, trying. That was an important lesson that I learned by the time we took over the building. I had learned that the greatest obstacle to being truly free is fear.

We've been here 30 years. Now thousands of people of all ages come here to learn, read, write, grow, and talk about what's happening in the world. We have programs for little kids, for elders, for young people in between. We find jobs for people, and we feed people who don't have any food. We send out young people to study in other places in the world. We have baptisms, wakes, memorials. It's a three-ring circus. I'm not sure how it all happened, but it's a beautiful place because everybody's welcome. We sing, we dance, we party, we work, we rejoice, we learn, we argue, we bicker, we make foolish mistakes, and we try to correct them, and we love everybody. That's what we do.

In 1999, after many years of complicated lease arrangements, the Seattle School District, working with the City of Seattle, sold the old Beacon Hill School building to El Centro de la Raza. Since its inception, El Centro has often been a target of criticism for its leftist politics. It has also won numerous awards and commendations for its important social services work. El Centro received recognition from former governor Booth Gardner for outstanding community service, and Roberto Maestas has been recognized by King County Municipal League as an Outstanding Citizen. They have also received international awards for their work promoting justice, peace, and aid for people from Nicaragua, Chile, and Cuba. Historically, El Centro has provided public assistance for up to 20,000 people per year. They have operated a large food bank, Head Start classes, a day-care center, housing assistance, a senior center, job placement workshops, and a program called "Hope for Youth," to address the needs of at-risk youth. Their funding comes from a variety of public and private sources, including the federal government, the state and the city, as well as private donations. El Centro has also provided space for other organizations over the years, including the Seattle Samoan Community Center, Seattle Conservation Corps, North Beacon Hill Neighborhood Planning, and the Share/Wheel temporary tent village for the homeless. Currently, the site is also home to the Seattle Midwifery School.

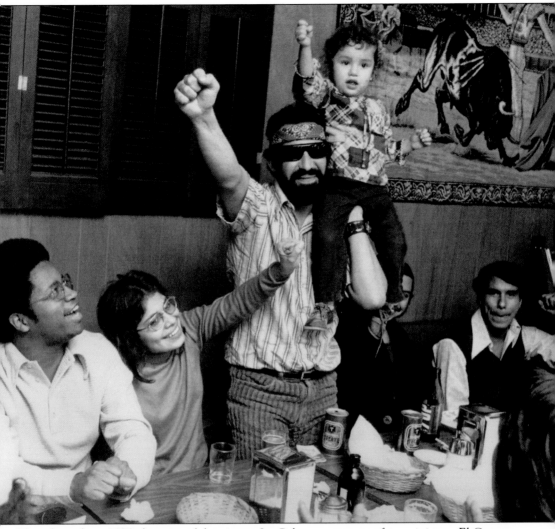

This photo from 1972 shows a celebration at La Cabana restaurant for activists at El Centro de la Raza, who were given permission to operate social services at the old Beacon Hill School. Shown here, from left to right, are Larry Gossett, Estella Ortega, Roberto Maestas, and child. (*Seattle Post Intelligencer.*)

This photo shows daycare on the steps of old Beacon Hill School during the occupation of the building by War on Poverty activists led by Robert Maestas in 1972. (*Seattle Post-Intelligencer.*)

In 1973 a meeting with Roberto Maestas was held in the front hall of old Beacon Hill School during the occupation of the building. (El Centro de la Raza.)

Larry Gossett and Roberto Maestas are shown here in 1972 in the city council chambers listening to testimony on behalf of the effort to use the old Beacon Hill School for social services. (El Centro de la Raza.)

Sam Martinez, in 1988, is shown here on Apple Brigade to Yakima. (El Centro de la Raza.)

Shown here is the 1989 peace delegation to Nicaragua. Pictured is Thomas Borge, "Ronald Reagan's worst nightmare," the Minister of Foreign Affairs in Nicaragua. (El Centro de la Raza.)

Freddie Mae Gautier is seen here in 1990 with Elisa Miranda for the Youth and Elders project sponsored by the Intiman Theater. (El Centro de la Raza.)

Ernie Aguilar is seen with Alex Bautista for the Youth and Elders project in 1990. (El Centro de la Raza.)

A mural by Alejandro Canalez in the Mural Room at El Centro de la Raza is shown here in 1990. (El Centro de la Raza.)

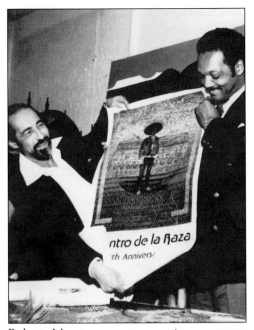

Roberto Maestas presents an anniversary poster to Rev. Jesse Jackson on his visit to El Centro de la Raza in 1983. (El Centro de la Raza.)

This photo from 1990 shows Roberto Maestas with Noel Campbell at Pearl Lagoon, Nicaragua. (El Centro de la Raza.)

Phillipe Perez Roque, minister of foreign affairs in Cuba, led the 40-member Cuban delegation to the WTO meeting in Seattle in 1999. On the steps at El Centro with Estella Ortega are Mr. Roque, Roberto Maestas, and Ricardo Aguerre. (El Centro de la Raza.)

Ramon Soliz, Henry Cisneros, and Ricardo Sanchez visit El Centro in 1987. (El Centro de la Raza.)

Neighbor Hop Bocklie, Roberto Maestas, and Estella Ortega at El Centro de la Raza for a visit by Reverend Jesse Jackson in 1990. (El Centro de la Raza.)

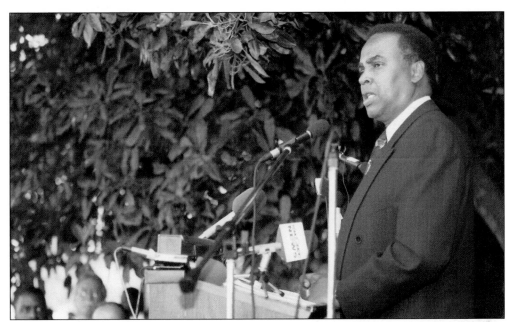

Mayor Norm Rice speaks at El Centro de la Raza in 1990 during a visit by Reverend Jesse Jackson. (El Centro de la Raza.)

Ruhino Martinez, California Representative Maxine Waters, David Elias, and Alex Bautista are shown here at a Democratic fundraising event in 1994. (El Centro de la Raza.)

Beacon Hill neighbors weed planting beds at El Centro de la Raza on Earthday in 1995. (El Centro de la Raza.)

Roberto Maestas is shown with brother Francisco Maestas in 1990. (El Centro de la Raza.)